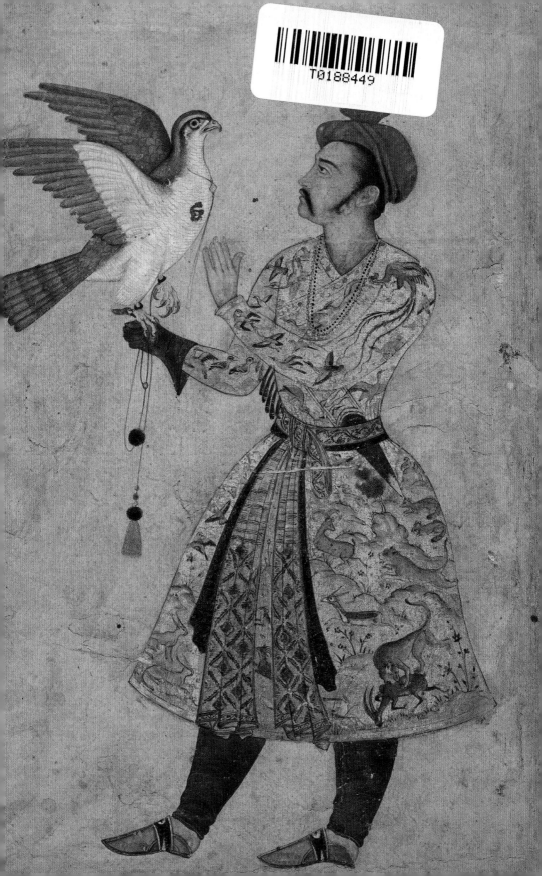

LOOKING AT
FASHION

A Guide to Terms, Styles, and Techniques

DEBRA N. MANCOFF

J. PAUL GETTY MUSEUM
LOS ANGELES

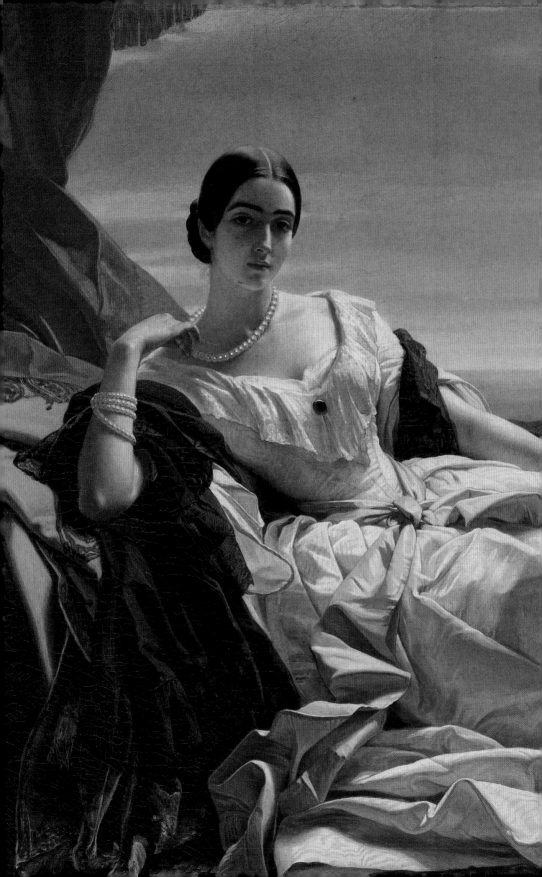

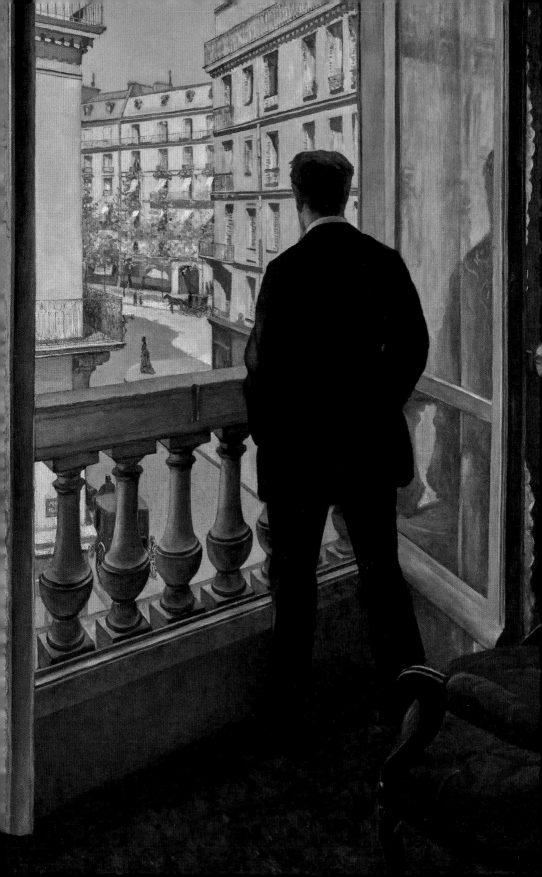

Introduction

Vain trifles as they seem, clothes have, they say, more important offices than to merely keep us warm. They change our view of the world and the world's view of us.

— Virginia Woolf, *Orlando: A Biography*, 1928

After thirty years of living as a man, the gender-fluid protagonist of Virginia Woolf's novel *Orlando: A Biography* (1928) discovers the transformative power of clothing. A tight bodice and sweeping skirts not only assert the public identity of "Lady Orlando," but prompt a change in treatment from the men *she* now encounters. On the deck of a ship, the captain showers her with chivalrous attention, securing an awning to shade her from the sun. When dining, she is offered the choicest serving of the roast, a small and tender slice to suit her presumedly delicate appetite. And even more remarkably, as Orlando becomes accustomed to her new attire, she notices changes in her own manner. Trading close-cut breeches for layers of skirts impedes her freedom of movement, and her demeanor becomes more compliant, more inclined to charm and flatter. Dressed as a woman, she feels like a woman. With her garments proving to be more than "vain trifles," Orlando surmises that "there is much to support the view that it is clothes that wear us and not we them."[1]

Whether in life or in art, clothing has a tale to tell. What we wear connects us to time and place, community and circumstance, identity and individuality. There is an essential wisdom in a line of advice that Polonius gives his son Laertes in William Shakespeare's *Hamlet*: "The apparel oft proclaims the man."[2] When this adage is applied to Gustave Caillebotte's *Young Man at His Window* (1876) or the Mughal-era portrait *Prince with a Falcon* (1600–1605), we can dispel some of the subjects' titular anonymity. Despite a time difference of more than two centuries, both figures wear what has become recognized as male attire—a jacket and trousers—but the cut and the fabric clearly set them apart. The prince's *jāma*—a long coat often fitted and flared—was the signature garment worn by men of rank during the Mughal era (1527–1857) in South Asia. Paired with slim trousers, the open-front *jāma* would have provided ease of movement, while its richly embroidered brocade signified elite status. The man at the window is far more modestly dressed. His sack jacket and straight-legged trousers—worn by middle-class men in mid-nineteenth-century Europe—hang loosely on his frame, turning his body into an undifferentiated black silhouette. One man's ensemble commands attention; the other deflects it. Each individual item of apparel, as well as its fit and construction, can be read for content about age, era, and social circumstance, but only with an understanding of the context in which it was worn. And that context is fashion.

Opening sequence:
Franz Xaver Winterhalter (German, 1805–1873), *Portrait of Leonilla, Princess of Sayn-Wittenstein-Sayn*, 1843. Oil on canvas, 142.2 × 212.1 cm (56 × 83½ in.). Los Angeles, J. Paul Getty Museum, 86.PA. 534

Opposite page:
Gustave Caillebotte (French, 1848–1894), *Young Man at His Window*, 1876. Oil on canvas, 116 × 81 cm (45 11/16 × 31 7/8 in.). Los Angeles, J. Paul Getty Museum, 2021.167

9

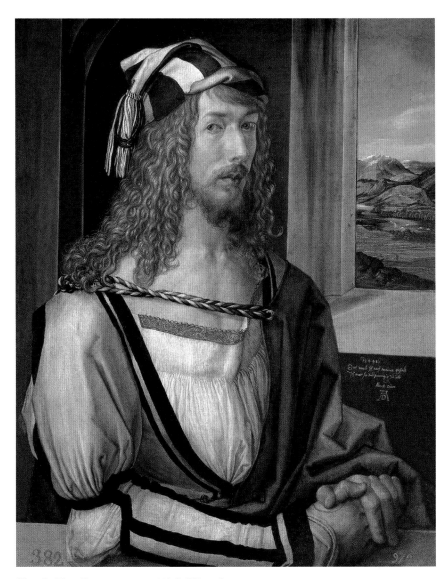

Albrecht Dürer (German, 1471–1528), *Self-Portrait as "Gentiluomo,"* 1498. Oil on poplar panel, 52 × 41 cm (20½ × 16⅛ in.). Madrid, Museo Nacional del Prado, P002179

The contemporary use of the word "fashion" evokes glamour: high-end designers, the latest trends, extravagantly garbed models striding a runway. In this sense fashion implies change, something exciting but evanescent. In our current world, fashion is commercialized. From couture-crafted garments to brand names to affordable knockoffs, we announce to the world who we are through the labels we wear. But the word's origins carry a meaning far more expressive of material substance than materialistic display. According to the *Oxford English Dictionary*, the word "fashion" surfaced around the fourteenth century in reference to making, building, or shaping something with attention to visible characteristics. Within a century, the idea of

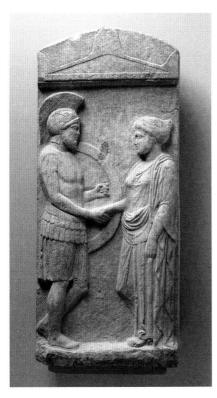

Greece (Attica), Grave stela of Philoxenos with his wife, Philoumene, ca. 400 BCE. Marble, 102.2 × 44.5 × 16.5 cm (40¼ × 17½ × 6½ in.). Los Angeles, J. Paul Getty Museum, 83.AA.278

fashioning became associated with an individual's public self-presentation and included manners, possessions, and lifestyle as well as attire. When the painter Albrecht Dürer wrote to his friend Willibald Pirckheimer, "My French mantle greets you, and so does my Italian coat," he was not just touting his elegant new garments; he was putting himself forth as a cosmopolitan gentleman—sophisticated, well traveled, and wealthy enough to afford the best.[3]

Dürer made his playful boast fully confident that Pirckheimer would understand his meaning. This manner of dress, after all, was a type of performance, informed not just by a garment's cut, origin, and quality, but by its social significance as well. Both men understood the same language of style because they shared the same social situation and cultural references. They read these garments within the context of then-contemporary fashion. Centuries on, we have to reconstruct that context to decipher the meaning; the garments must be regarded as cultural objects created at a particular time and place for a particular purpose. And, as in every area of visual culture, a historical investigation of fashion must take account of limited samples, misconceptions, and biases.

The best way to understand historical clothing is to study actual garments, but those that have survived skew our perspective. Garments made for and owned by the elite classes were crafted out of fine materials, lightly worn, and likely to be preserved. The wardrobes of working and poor populations were regarded as durable goods—an investment that saw hard and often constant use, and then, if salvageable, was passed on or repurposed. For example, a nineteenth-century British agricultural laborer might acquire a suit for his wedding. In the ensuing years he would wear it to church services and significant events until it became shabby, and then he would wear it in the fields. Visual records of garments in paintings, prints, and photographs also must be approached with caution. Just as a painter might flatter a sitter in a commissioned portrait, their clothing could be imaginatively improved in quality, style, or fit. And print images—from historic and anthropological illustrations to fashion plates—do not represent the garments on real bodies; these too were likely "improved" for visual appeal. Photography is far more reliable in documenting clothing, but fashion photography is styled as well, in that the garments are presented on distinctive body types and recorded at their best advantage.

The Eurocentric bias in the foundational studies of fashion history calls for even more caution. A relatively young discipline in the history of art, fashion history has its roots in the illustrated publications, private and museum collections, and hierarchical taxonomy of nineteenth-century European-influenced scholarship. Up until late in the twentieth century, many survey publications relied for their examples almost exclusively upon depictions of costumes in paintings, and representations from regions other than those that shared European roots were either absent or relegated to a separate "world costume" section. In public collections, global garments were often regarded as artifacts rather than attire, and categorized solely by region or culture with little acknowledgment of an evolving history. Whether based on bias or lack of information, two separate fashion histories persisted, both seen through the European/North American lens of social standing, gender identification, dress decorum, and pace of stylistic change. In recent decades, this bias is being countered by expanding representations in historic costume and study collections, more diverse and globally themed exhibition programs, and a redefinition of the ways we conceive fashion in terms of history and contemporary design. The enduring misconceptions that have distorted our understanding of dress over the centuries and across cultures—fashion began in fourteenth-century European courts; fashion began with European-style tailoring; fashion never changes in non-Western and traditional cultures—are being corrected with broader, deeper, and more balanced interpretations of the expressive power of clothes.

So how can we begin to understand the content of fashion? Commenting upon the difference between art and fashion, mid-twentieth-century designer Elsa Schiaparelli offers a place to begin: "A dress has no life of its own unless it is worn."[4] This straightforward observation reminds us of the utility of clothing. We wear garments for warmth, protection, and modesty, as well as for display. Some types of attire—robes, wraps, trousers, footwear, gloves—appear to be universal. We may not have seen a specific variant or know its cultural name or significance, but through its form we can recognize an essential function. There is an element of empathy in this recognition; we can imagine how an item feels on our body. Does the fabric of the garment flow, as seen in the chiton and himation worn by the woman represented on the grave stela of Philoxenos and Philoumene? Draping, one of the basic methods of clothing construction, is a general term for arranging fabric on the body and securing it by tying, tucking, or the insertion of a few stitches or a pin. Clothing may also be constructed to fit the body. In tailoring, the fabric is cut and then stitched, as seen in the trim, form-fitting jackets featured in Norman Parkinson's fashion photograph *Golfing at Le Touquet* (1839). In draping and wrapping, the body shapes the garment, while in tailoring, the garment creates a shape over the body. Either method can be found in some version throughout time and across cultures.

There is much to be learned through recognizing universal elements of dress and basic modes of construction, and imagining what it would feel like to wear the clothes. But to expand the meaning of attire beyond our own experience, we need a way to situate individual garments in their appropriate contexts. The silhouette of a garment—defined by the breadth at the shoulders, waist, and hem—can link it to a particular time and place. Think of the difference between the form-skimming medieval kirtle, the full-blown European hoop skirt of the mid-1800s, and the close-fitted cheongsam of prerevolutionary China. Style lines are the features within the silhouette—seams, collars, cuffs, closures—that give an item of clothing its

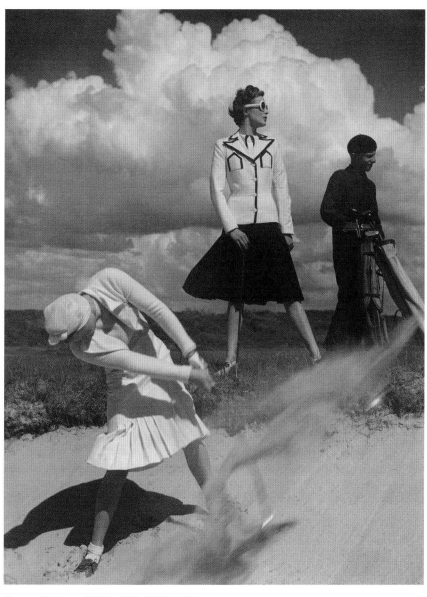

Norman Parkinson (British, 1913–1990), *Golfing at Le Touquet*, 1939. Gelatin silver print, 40 × 28.5 cm (15¾ × 11¼ in.). Los Angeles, J. Paul Getty Museum, purchased with funds provided by the Photographs Council, 2016.89.1

individual look. These may be practical and indicate how a garment fits and functions, as with the gores in a skirt or the front panel in a pair of trousers. As sites of fine differences—the height of a collar, the folds in an obi, the vent in the back of a jacket—they narrow the date from an era to a decade or even a particular year. Ultimately, garments and habits of dress are temporally and culturally specific, and so without the correct context, we cannot fully understand their content.

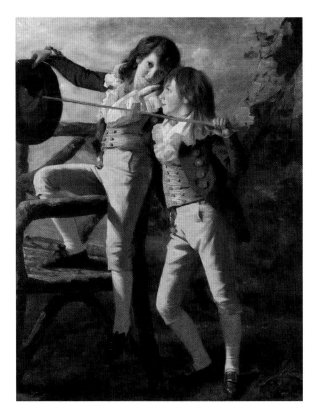

Henry Raeburn (Scotland, 1756–1823), *The Allen Brothers (Portrait of James and John Lee Allen)*, early 1790s. Oil on canvas, 152.4 × 115.6 cm (60 × 45½ in.). Fort Worth, Kimball Art Museum, AP 2002.05

Within every society there are dress codes that apply to social rank and status, occupation and affiliation, ceremony and activity, as well as age, gender identity, and family circumstance. A dress code may be imposed through the authority of a government, by religious practice, or through employment, but compliance may also be self-selected to demonstrate membership in a community of choice. Dress codes can accommodate individual expression, ranging from a small departure from the standard—in fit, fabric, or decorative addition—to the complete rejection of prevailing conventions. Our choices reflect not simply who we are, but who we want to be. Both openly public and highly personal, what we wear expresses our identity. Performer and media producer RuPaul reminds us: "We are all born naked—the rest is drag."[5]

One of the common conventions of dress is to wear attire appropriate to age and life circumstance. Until fairly recently, children's garments in most cultures were non-gendered from infancy until the attainment of a particular skill such as toilet training or walking. A child went from loose attire chosen for convenience—a frock or an apron—to a version of adult clothing. The Allen brothers, both under ten years old when painted by Henry Raeburn, wear double-breasted jackets, silk waistcoats, and drop-front panel breeches—a country gentleman's ensemble scaled down to their small frames. Their large, double-frilled collars are a stylistic concession to their youth. Their breeches have back laces and plain hems designed to accommodate a growth spurt.

Specific attire is often used in such ceremonial events as initiation into a religious or social community, marriage, or childbirth, or to mark status within a family.

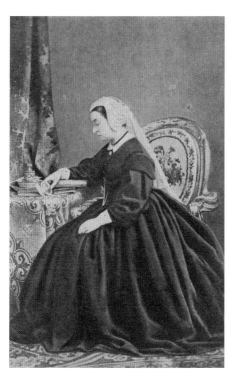

Ghémar Frères (founded 1859; dissolved 1894), *Queen Victoria Gazing at a Photograph of Prince Albert*, ca. 1862. Albumen silver print, 8.4 × 5.4 cm (3⁵⁄₁₆ × 2⅛ in.). Los Angeles, J. Paul Getty Museum, 84.XD.697.15.93

Artist unknown (British, 16th century), *Portrait of Elizabeth I, the Armada Portrait*, ca. 1588. Oil on oak panel, 110.5 × 125 cm (43½ × 49¼ in.). Greenwich, London, National Maritime Museum, ZBA7719

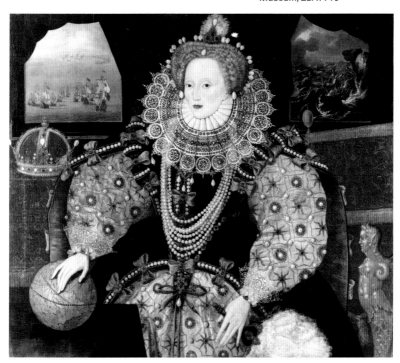

Most cultures dictate mourning attire, particularly for widows. In communities across the globe, widows have worn white to evoke purity and rebirth. But like the all-black ensemble popularized by Queen Victoria, who extended her display of mourning for four decades, the color also deflected attention so as to protect a woman during her grief. Victoria only abandoned her own widow's weeds at death; she was buried in her white bridal lace.

The practice of proclaiming status through dress is universal, but the styles, symbols, and materials are culturally specific. The royal ermine and velvet draping the shoulders of a European monarch has an equivalent in the feather mantle of

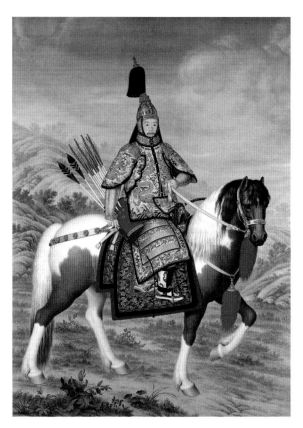

Giuseppe Castiglione (Italian, 1688–1766; Chinese name Lang Shining), *The Qianlong Emperor in Ceremonial Armor on Horseback*, 1739 or 1758. Ink and color on silk, 322.5 × 233.2 cm (127 × 91⅞ in.). Beijing, Palace Museum, Gu8761

a Hawaiian chief. Headdresses and crowns, capes and robes, distinguish leaders from their subjects. In *The Armada Portrait* (ca. 1588), Queen Elizabeth I is adorned with pearls, which at the time were as precious as gold. But it is the lavish carapace of her garments and the starched nimbus of her lace ruff that transform her from a mortal woman into an embodiment of sovereignty.

The Qianlong Emperor's riding attire pays tribute to his Manchurian ancestors, who were renowned for their expert horsemanship. The silk satin of his quilted, high-collared jacket and split skirt is a brilliant yellow known as *ming huang* that proclaims his imperial identity. Sumptuary codes, imposed by governments and religious organizations, control attire in terms of fabric, color, style, and ornament

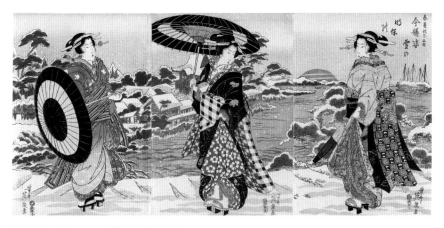

Ikeda Eisen (Japanese, 1790–1848), *Modern Figures at Dawn on a Snowy Day,* from *The Four Seasons*, 1830s. Color woodblock print, 36 × 75.5 cm (14 3/16 × 29 3/4 in.). Massachusetts, Worcester Art Museum, John Chandler Bancroft Collection, 1901.146

to prevent class confusion. Clothing display that signifies wealth offers an insight into what matters to a society. The layers of silk kimono depicted in Ikeda Eisen's 1830s woodblock print *Modern Figures at Dawn on a Snowy Day* do more than keep these elegant women warm; they are a costly display that signals family affluence and the women's exquisite taste in mixing color and pattern.

The enforcement of modesty codes in orthodox societies demonstrates public adherence to moral principles. And etiquette, whether as a learned social code or a matter of following perceived practice, dictates dress for specific occasions. Uniforms—whether military, corporate, or service—announce affiliation and authority, and variations in cut, color, and trim designate rank. Dress can define individual identity within the context of community. This is particularly evident in the presentation of gender. Many elements of dress—robes, capes, jackets, vests, wrappers—are not inherently gender specific. It is the way they are modified and worn that conveys a particular culturally based message about who is wearing the garment. The message can be overt, responding to and enforcing the social codes of gender, as seen in Isabel Bishop's painting *Encounter* (1940).

Isabel Bishop (American, 1902–1988), *Encounter*, 1940. Oil and tempera on Masonite, 60.3 × 40 cm (23 3/4 × 15 3/4 in.). Saint Louis Art Museum, Eliza McMillan Trust, 19:1942. © Estate of Isabel Bishop York

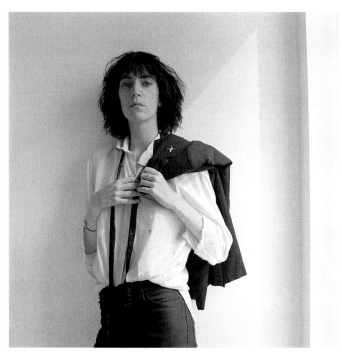

Robert Mapplethorpe (American, 1946–1989), *Patti Smith*, negative 1975, print 1995. Gelatin silver print, 35.8 × 35.5 cm (14⅛ × 14 in.). Los Angeles, J. Paul Getty Museum and Los Angeles County Museum of Art, jointly acquired by the J. Paul Getty Trust and the Los Angeles County Museum of Art, with funds provided by the J. Paul Getty Trust and the David Geffen Foundation, 2011.7.1. © Robert Mapplethorpe Foundation. Used by permission

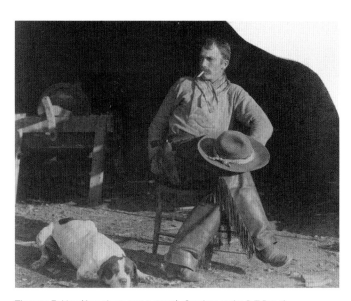

Thomas Eakins (American, 1844–1916), *Cowboy at the B-T Ranch, Missouri Territory*, 1887. Albumen silver print, 8.7 × 11.3 cm (3⅞₆ × 4⅞₆ in.). Los Angeles, J. Paul Getty Museum, 84.XM.155.33

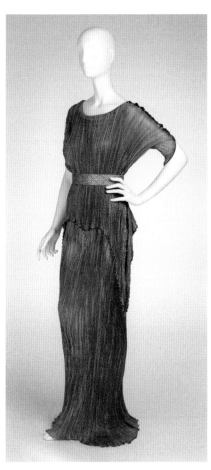

Mariano Fortuny y Madrazo (Spanish, 1871–1949), Peplos Gown, 1920–30. Silk, glass. New York, Metropolitan Museum of Art, promised gift of Sandy Schreier, L.2018.6161a,b

The couple in *Encounter* both wear suits. Informed by the mores of the mid-twentieth-century United States, each conforms to the dominant masculine or feminine binary. The man's loosely cut jacket and trousers amplify his silhouette, while the woman's jacket and skirt sleekly define the contours of her figure and expose her lower legs. But differentiation can be more nuanced. The upper garment of a man's *hanbok*, for instance, is cut only slightly longer than a woman's. Kimono distinguish gender through color, embellishment, and how the garment is secured. Prohibitions in many cultures against wearing garments associated with a gender other than that established by biology is evidence that clothing is a powerful tool of identity. Even without prohibitions, crossing the lines, as Patti Smith does in her androgynous attire, presents a strong challenge to conventional perceptions.

Some items of clothing may have functional origins, then eventually accrue greater meaning. The leather chaps and neckerchief worn by the unnamed cowboy in Thomas Eakins's photograph were designed to stand up to hard riding and the rigors of ranch work. But features of his utilitarian gear have become romantic symbols of the US West, adopted as "Western wear" in casual clothing across the globe. His chaps connect his garments with a tradition other than his own; they are based on the leather leggings worn by Native peoples across the North American continent. Constructed in two parts that fasten at the waist, a length of cured hide wraps and protects the rider's leg. The outer seam could be finished with fringe or beading, depending upon regional traditions.

Adaptation of another culture's garments may, as in this case, be practical. It may also provide a means of establishing cultural continuity, as seen in Mariano Fortuny y Madrazo's supple pleated gowns that pay homage to the silhouette of the ancient Greek chiton. But there is a fine and blurry line dividing adaptation and appropriation. Garments worn out of their context can announce alliance—for instance wearing a keffiyeh to symbolize support for an independent Palestinian state—or cause offense.

The seated woman in William McGregor Paxton's *The New Necklace* (1910) wears a *ru* jacket, derived from the imperial style of the Manchu dynasty. She pairs this ceremonial garment with a petticoat as loungewear, expressing either ignorance or indifference to the garment's significant origins.

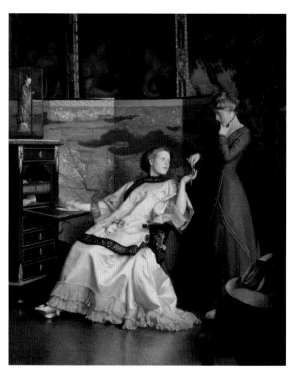

William McGregor Paxton (American, 1869–1941), *The New Necklace*, 1910. Oil on canvas, 91.8 × 73 cm (36⅛ × 28¾ in.). Boston, Museum of Fine Arts, Zoe Oliver Sherman Collection, 22.644

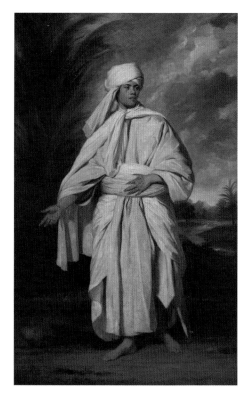

Joshua Reynolds (British, 1723–1792), *Portrait of Mai* (formerly known as *Portrait of Omai*), ca. 1776. Oil on canvas, 236 × 145.5 cm (92⅞ × 57¼ in.). London, National Portrait Gallery / Los Angeles, J. Paul Getty Museum, purchased jointly by the J. Paul Getty Trust and the Board of Trustees of the National Portrait Gallery, London, 2023. Support provided to the NPG by the National Heritage Memorial Fund, Art Fund, and other generous supporters, 2023.18

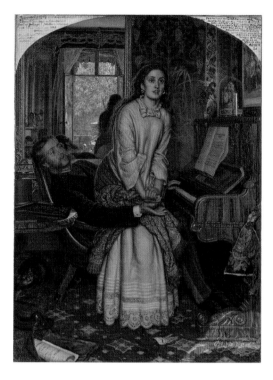

William Holman Hunt (British, 1827–1910), *The Awakening Conscience*, 1853. Oil on canvas, 76.2 × 55.9 cm (30 × 22 in.). London, Tate Gallery, presented by Sir Colin and Lady Anderson through the Friends of the Tate Gallery 1976, T02075

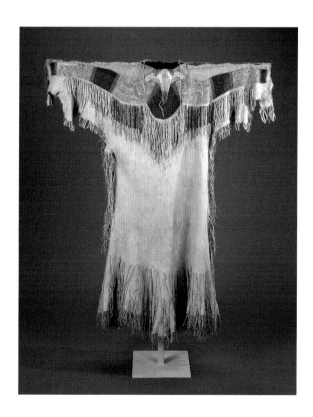

Dress, Nez Percé, 1890s. Leather, glass beads, and fur. Denver, Denver Art Museum, the L. D. and Ruth Bax Collection, 1985.42

But in other hands and other circumstances, appropriation helps construct an identity for public or professional performance. In the late nineteenth century, the writer and art dealer Okakura Kakuzō always wore a kimono when visiting his European and American clients, but favored European tailored suits when at home in Japan.

A century earlier, when the young Polynesian man Mai was brought to Great Britain in 1774 for a two-year stay—the first known visitor from his region—he too used dress to impress his foreign hosts. He devised ensembles that exaggerated his "exotic" image, including a robe resembling a Middle Eastern djellaba and a turban. And while it is speculated that his sash was made of tapa cloth—a bark textile widely used in South Sea Island culture—only the tattoos on his hands attested to his authentic identity.

Fluency in the language of fashion—in terms of its components and as a context—can uncover rich meaning in cultural expression. The decorum of dress is key, for instance, to the narrative of William Holman Hunt's moralist message in *The Awakening Conscience* (1853). With unbound hair and an uncorseted body beneath a nightgown, a woman rises from the lap of her blithe—and fully dressed—companion. The fact that she has a ring on every finger except the third on her left hand did not escape a few sharp-eyed critics. But a more obvious clue to the woman's suspect circumstance would have been readily evident to viewers at the time. No respectable woman—married or single—would appear in her parlor in nightwear. Critic John Ruskin saw the woman's intimate garment as a harbinger of her fate, predicting that the lace trim of "the poor girl's dress," which, rendered "thread by thread[,] has story in it," and will soon be dragging through the "dusty streets."[6]

Sometimes the garment itself tells the story. The dress, likely deerskin, was made by and for a Nez Percé woman. Fabricated out of two large cured hides, the distinctive design involved turning down the hindquarters of each and seaming the edges to form the shoulder line. The fold creates a loose yoke over the back and front that is emphasized with beadwork. The garment is organically gendered; traditionally only skins of female animals were used, often arranged so that the udders fall at the elbows, and open to allow the wearer to nurse an infant.

To understand fashion, we must see beyond the limits of personal taste and prevailing style. Every item of attire has its parts, its purpose, and a past rooted in design and production. These are the universal components that underlie habits of dress across centuries and cultures. Whether it is the way a wrapper is secured or a cloak is draped, the tailoring of a jacket or the undergarments that shape the body, making informs meaning. These methods, and the forms that they craft, constitute the language of fashion. With definitions and explanations ranging from the elements and construction of specific garments to the embellishments, variations, and innovations that give them distinction, *Looking at Fashion: A Guide to Terms, Styles, and Techniques* offers a richly illustrated overview of modes and methods of clothing from antiquity to the present. Focusing on garments and their fabrication, this handbook goes beyond the realm of labels, brands, designers, and trends to provide a broadranging vocabulary of the forms, structures, and substance that give clothes eloquence. The aspiration, in talking about clothing with clarity and precision, is to start a new and more relevant conversation about these "vain trifles" we wear.

1 Virginia Woolf, *Orlando: A Biography* (New York: Houghton Mifflin Harcourt, 1928), 187–88.

2 William Shakespeare, *Hamlet* (1599–1602), act 1, scene 3, line 72. The related adage "clothes make the man" is often mistakenly attributed to Mark Twain, "The Czar's Soliloquy," *North American Review*, March 1905, but has much deeper origins. A notable precedent is the proverb *vestris virum facit*, recorded in Desiderius Erasmus's *Adagiorum Chiliades*, an early sixteenth-century compilation of Greek and Latin proverbs (three editions: 1500, 1508, and 1536).

* Illustrations throughout by A. E. Kieren

3 Albrecht Dürer to Willibald Pirckheimer, Venice, September 8, 1506, in *Memoirs of Journeys to Venice and the Low Countries by Albrecht Dürer*, ed. Lewis Einstein, Humanist's Library VI, available at https://www.fulltextarchive.com/book/Memoirs-of-Journeys-to-Venice-and-the-Low/.

4 Andrew Bolton and Harold Koda, eds., *Schiaparelli and Prada: Impossible Conversations* (New York: Metropolitan Museum of Art, 2012), insert between pp. 144 and 145.

5 RuPaul interviewed by Oprah Winfrey, Super Soul Sunday/OWN, May 26, 2015, available at https://www.youtube.com/watch?v=9RPDSdRCDYs.

6 "The Author of 'Modern Painters' (John Ruskin)," *The Times* (London), May 25, 1854.

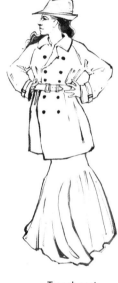

Trench coat

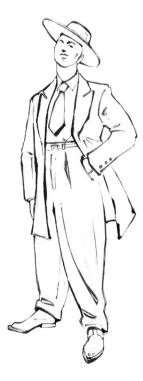

Zoot suit

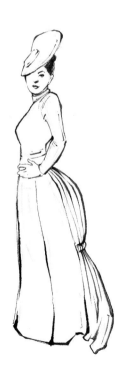

Tie-back skirt

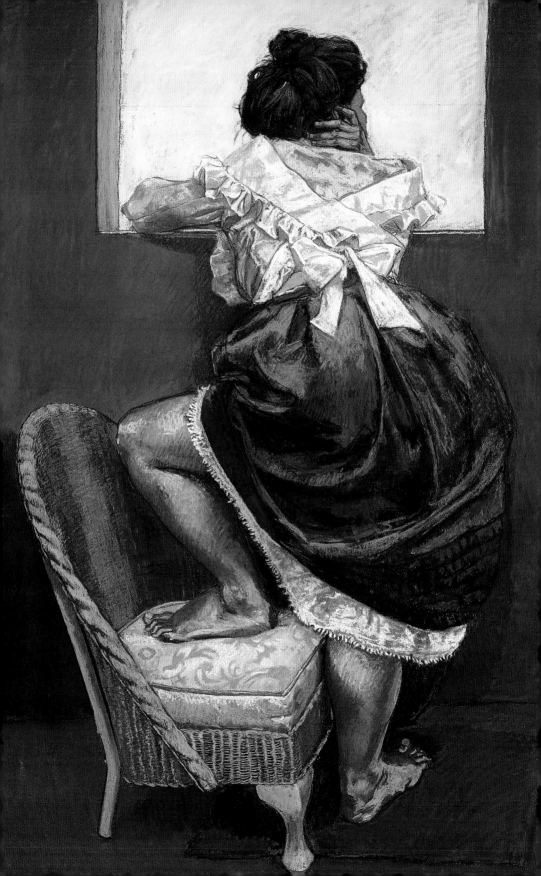

Guide

Appliqué

A needlework technique in which shaped fabric pieces are sewn onto a foundation fabric. With practical origins in patching worn textiles, examples survive from ancient Egypt, Mongolia, and Siberia. Distinctive clothing traditions with ornamental stitching span the globe, from Moroccan slippers to Eastern European aprons to the poodle skirts that were popular in the United States in the 1950s.

Apron

A protective garment worn at the front of the body to keep clothing from being soiled. The derivation of the term—from the French word *naperon* (tablecloth)—reflects its origins in the European medieval practice of women covering their laps with a cloth while eating. But the basic form of the apron can be traced to most ancient cultures around the globe, worn for modesty, ceremony, or to denote fertility or maternity. During the Middle Ages in Europe, workers adopted aprons of sturdy cloth or leather, with the design and color linked to their trade. From the fifteenth century forward, decorative variants were worn as an ornamental fashion accessory by elite European women, while Eastern European countries developed rich national and ethnic traditions of embroidered aprons celebrating marriage and motherhood. In recent times, the apron is popularly associated with kitchen work—professional and domestic—and it served as a symbol of the middle-class housewife in advertising and popular entertainment in the mid-twentieth-century United States.

Bib apron A skirted form, secured by ties at the waist, with a simple square that covers the chest. Straps over the shoulders—circling the neck or crossing in the back—support the top.

Cocktail apron A decorative half apron, popular in the mid-twentieth century, designed to match or enhance a hostess's dress and worn while serving guests. The hostess would change into a more practical garment for work in the kitchen.

Half apron A skirt only, tied at the waist, that may be practical, ceremonial, or decorative.

Pinafore Similar to a bib apron, often trimmed with ruffles. The top square was originally pinned to the front of the wearer's dress. The term can also describe a child's overgarment, without collar or sleeves, that fastens in the back.

Paula Rego (British/Portuguese, 1935–2022), *Looking Out*, 1997. Pastel on paper, laid on aluminum, 179 × 129.5 cm (70½ × 51 in.). Sotheby's Contemporary Art Auction 1, Lot 38, July 2015

Housework and kitchen aprons are made of durable fabrics that can stand up to repeated washing, starching, and ironing. Here, edge ruffles and a large bow tie add embellishment without limiting practicality.

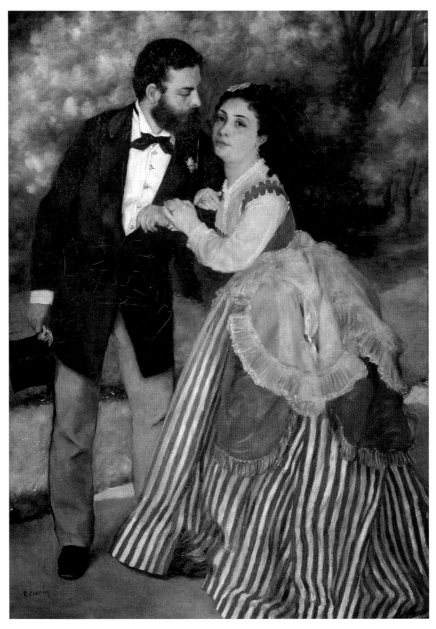

Pierre-Auguste Renoir (French, 1841–1919),
A Couple (*Les Fiancés*), ca. 1868. Oil on canvas,
105 × 75 cm (41 × 30 in.). Cologne, Wallraf-
Richartz-Museum & Foundation Corboud,
WRM 1199

A traditional *tablier* extends from the front
waistband, but here, following the bustle
silhouette, diaphanous teardrop panels are
arranged toward the back and sit on heavier,
elongated panels for further augmentation.

Tablier An overskirt made of shaped panels of light fabric that are often gathered
into puffs, worn at the front of a gown for a decorative effect.

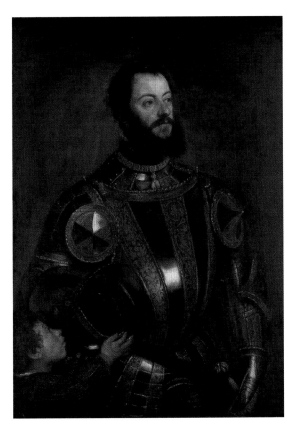

Titian (Tiziano Vercelli) (Italian, ca. 1487–1576), *Portrait of Alfonso d'Avalos, Marchese del Vasto in Armor with a Page*, ca. 1533. Oil on canvas, 110 × 80 cm (43⁵⁄₁₆ × 31½ in.). Los Angeles, J. Paul Getty Museum, 2003.486

Magnificent armor denotes status. Here, Alfonso d'Avalos, commander of the imperial forces of Charles V, the Holy Roman Emperor, also wears the royal collar of the Order of the Golden Fleece, awarded for successful military campaigns.

Armor

Protective wear worn for combat or sport. The earliest known versions were skins and hides layered to cover vulnerable parts of the body, especially the torso. The addition of metal in the form of overlapping scales has been traced back to 2000 BCE. A flexible metal mesh worn over padding by Imperial Roman soldiers developed into the chain mail worn in Western European nations during the late thirteenth and fourteenth centuries. By the fifteenth century, plate armor, forged out of individual elements and covering all parts of the body, created a highly defensive suit, often elaborately embellished for spectacular effect. The development of the crossbow and firearms in the West relegated full suits of armor to military sports and pageant wear. Notable armor designs can be found across the globe, with plates made out of mesh, forged metal, metal plate, molded leather, bone, and/or horn. Japanese samurai armor made of lacquered leather became an art form in itself. Modern armored garments include the flak jackets and bulletproof vests worn by military and law enforcement officers.

Romare Bearden (American, 1911–1988), *Quilting Time*, 1986. Mosaic tesserae mounted on plywood, 288.9 × 425.5 × 3.2 cm (113 ¾ × 167 ½ × 1 ¼ in.). Detroit Institute of Art, 1986.41, Founders Society purchase with funds from the Detroit Edison Company

Long associated with US agricultural labor, a bandanna can protect the skin from the sun, prevent inhalation of dust, absorb perspiration, and, as seen at right, add a touch of bright color to working wear.

Armscye

A garment construction term describing the contoured opening to which a set-in sleeve is attached; also a general term for the opening for the arm, whether or not a sleeve is attached. Traced to Scotland, the word is believed to be a contraction of "arm's eye."

Bandanna

A fabric square, usually cotton, folded into a triangle and tied around the head, the neck, or the nose and mouth. The term's origin is the Hindi *bāndhnū,* referring to a tie-dyeing technique. Bandannas protect against sunburn and dust inhalation, and absorb perspiration. Their typically bright colors and bold designs also make them appealing as a decorative accessory.

Bandeau

A ribbon, metal strip, or fabric band worn as an item of apparel. Plain or embellished, a bandeau, named for the French diminutive of "band," may serve as a headdress; the term also refers to the decorative band encircling the base of a hat above the brim, or a band stitched inside a hat to make it smaller. Alternatively, it can be a band-shaped garment for the upper body (usually strapless) that covers and binds the breasts, worn as an undergarment, a revealing top, or the upper part of a swimsuit (SEE SWIMWEAR; UNDERGARMENTS).

Basque

Panels in the form of a U or a V, tabs, or tails attached to the waist seam of a garment. Originally referring to extensions over the hips at the hem of a doublet (SEE JACKET/DOUBLET) or waistcoat, by the 1800s the term applied exclusively to a woman's bodice. In the early twentieth century, "basque" also described a long CORSET with bra cups that covers the hips (SEE BODICE/BASQUE).

Belt

A strip of fabric or leather, a length of cord or rope, or a chain encircling the body to gather in or support clothing at or near the waist. A belt may be tied or secured with a buckle. Luxuriously decorated belts, known as girdles, were given in betrothal, embellished with heraldic symbols, or bestowed to signify a distinction or rank by European elites during the Middle Ages. Sturdy belts with loops or pouches (for instance sword belts and gun belts) are designed to carry weapons, and in recent times, belts, often with ornate metal plates over the central buckle, are awarded in sports championships. Belt loops began to be featured on men's trousers in the early twentieth century, but did not become common until the 1920s. Distinctive belt forms appear throughout history and across cultures (SEE OBI; SASH).

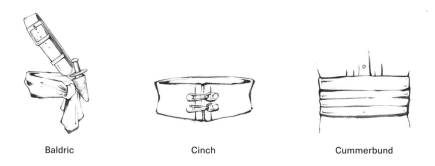

Baldric Cinch Cummerbund

Baldric A strongly made belt with a cross-body shoulder strap designed to hold a weapon (dagger or sword) or a musical instrument carried while marching (drum or bugle). Baldrics have been traced through many ancient cultures as military or ceremonial accessories.

Bandolier A variant on the baldric, designed with loops to hold bullet cartridges and supported with a strap over each shoulder (SEE BELT/BALDRIC).

Cinch belt A wide, often elasticized belt, laced or hooked, meant to accentuate the waist.

Cowboy belt A leather belt supporting a gun holster associated with the North American Western frontier. Often featuring decorative leatherwork and an ornate buckle, these belts are also worn as decorative accessories by men and women today.

Cummerbund A broad fabric band, often pleated, that fastens in the back. Adopted from the Anglo-Indian *kamar-band* (loin band), cummerbunds became popular in European menswear in the late nineteenth century as a substitute for a waistcoat in semiformal evening dress (SEE SUIT/TUXEDO).

Half-belt A band that does not encircle the whole waist, most often placed at the back for decorative effect. It may be stitched in place, sewn into side seams, or inserted as a separate piece. Variants include the martingale, which is positioned at the back either just above or just below the waist.

Sam Browne belt A military belt, similar to a baldric, with the strap positioned on the right shoulder (SEE BELT/BALDRIC). It was adopted by the US and British military in the twentieth century from a belt designed for the injured British General Samuel Browne, who could not hold his sword without additional support.

Self-belt A belt of any design made or covered with the same textile as the garment.

Bias

The technique of cutting garment pattern pieces on the cross grain (at a 45 degree angle to the warp and the weft). The inherent stretch along the cross grain encourages the fabric to drape and cling along the lines of the body, and so bias-cut garments may include skirts, dresses, coats, and capes. Soft, light fabrics with a tight weave—silk, crepe, satin—work best. Bias-cut strips are also used as binding, particularly for a curved edge.

Bib

A panel inserted into or worn over the front of an upper garment. Derived from the Latin *bibere* (to drink), the term originally meant a protective cloth placed over the front of a garment while eating, and is still commonly used to describe the napkin-like cloth tied around an infant's neck. A bib can be a decorative or structural part of a garment in a square or rounded form. It can also refer to the upper front panel of an apron or overalls (SEE COVERALLS/OVERALLS); a loose-fitting sleeveless garment worn in sports to mark team affiliation; or a protective garment, such as the lead bib worn during X-ray exposure or the paper gowns worn by medical patients.

Blouse

A loose garment for the upper body, often made of a light fabric. In Western culture, the term first described the generously cut shirt worn by male laborers; by the middle of the nineteenth century, it increasingly, and then exclusively, referred to a woman's or child's garment, often tucked into the waistband of a skirt or trousers. From the 1860s to the 1890s, blouses, teamed with a plain skirt, became an affordable and practical alternative to a gown, particularly for middle- and working-class women (SEE SHIRT/SHIRTWAIST). Blouses may open at the back or front, or be pulled over the head, and style names often designate a decorative feature (bib, bow, jabot) or a cultural or geographic reference (Cossack, middy/nautical, peasant). Variations, worn by women, can be found throughout history and across the globe.

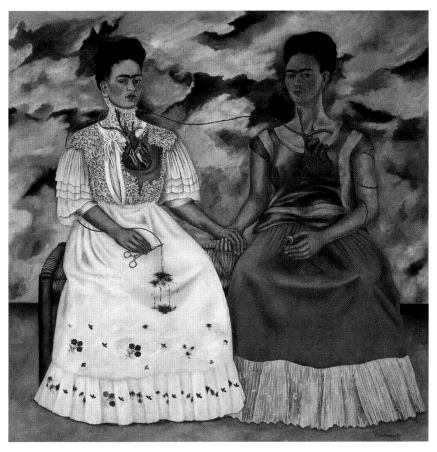

Frida Kahlo (Mexican, 1907–1954),
Two Fridas, 1939. Oil on canvas,
173.5 x 173 cm (68⅜ × 68 in.).
Mexico City, Museo de Arte Moderno

In her double self-portrait, Frida Kahlo uses
blouses to proclaim her dual heritage: a high-
necked lace and ruffled European design
with elaborate sleeves, and a capped-sleeve,
scoop-necked Mexican huipil trimmed with
vibrantly contrasting banding.

Choli A short, form-fitting, short-sleeved blouse traced to Mughal India
(SEE SARI).

Cossack blouse A full-sleeved long overblouse with a standing collar and an
asymmetrical closure. It is tied with a sash and trimmed with embroidered bands
on the collar, cuffs, and opening PLACKET.

Drawstring blouse A full-cut blouse of light fabric with a wide neckline that is
gathered and closed with a drawstring. With origins in Western agricultural labor,
it is commonly called a peasant blouse.

Huipil A square-cut cotton blouse pulled over the head and often embellished
with appliqué, embroidery, or lace. This traditional attire of women of the

Tehuantepec region on the west coast of southern Mexico has precedents in ancient Mayan and Aztec cultures.

Middy blouse A pull-on garment with long sleeves and a prominent, contrasting collar cut long and square in the back and angled to meet in a V in the front. The wide neckline is often filled with a dickie and finished with a tie (SEE NECK-WEAR/DICKIE). Based on the sailor's blouse of the nineteenth century, "middy" refers to a midshipman (officer of the lowest rank). It became a feature of boy's wear from the mid-nineteenth through the mid-twentieth century and was adopted by women for boating and tennis in the late nineteenth and early twentieth centuries.

Bodice

The upper portion of a woman's gown, covering the body from shoulders and neckline to the waist or below. It evolved from the late medieval and Renaissance upper-body support garment called a "pair of bodies," and was augmented with quilting or stays (SEE CORSET/STAYS) and worn beneath a gown for a smooth, stiff appearance. A bodice may be sewn to the lower part of a garment or designed as a separate piece; it may open in front, in the back, or at one side, and sleeves may be sewn in or detachable. Style lines vary according to prevailing fashion, but typically a bodice is fitted to the body through cut and via shaping techniques such as DARTS, PANELS, GORES, and GUSSETS.

Basque A tight-fitting bodice with corset-like boning and details, generally low cut or strapless.

Corsage Derived from the French *corps* (body) and used primarily in the mid- to late nineteenth century for a fitted, often formal bodice. It gives its name to a small bouquet of flowers pinned to a bodice.

Cuirasse A long, fitted bodice extending beyond the waist and over the hips, boned for stability. It is named for the cuirass, the combined breast and back plates of a suit of armor that protect the torso. This slim-line style was a distinctive European fashion feature from the mid-1870s through the early 1880s.

Dirndl A tight-fitting short bodice with lacing, usually sleeveless, with a low scoop or squared neck, worn over a chemise or blouse. It is a distinctive element of Germanic Alpine traditional dress (SEE CORSET/SWISS WAIST).

Dropped-waist bodice An elongated bodice that skims over the natural waist-line, ending anywhere from just below the waist to around the hip bones. Loose, and often featuring a wide neckline, it gives a TUNIC-like appearance to the upper silhouette. It was a popular fashion trend in the late 1910s through the 1920s and then again in the 1960s.

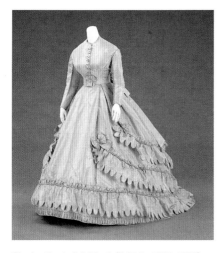

Charles Frederick Worth (British, 1825–1895), Ensemble, 1862–65. Silk. New York, Metropolitan Museum of Art, Brooklyn Museum Costume Collection, 2009.300.1372a–d, gift of the Brooklyn Museum, 2009; Designated Purchase Fund, 1987

This long-sleeved, high-necked bodice is buttoned rather than sewn to the skirt so that it can be switched for a short-sleeved evening corsage with a portrait neckline edged with gold-tipped lace.

Empire-waist bodice A very short bodice, ending just below the bustline. Associated with the late eighteenth- and early nineteenth-century Neoclassical style, it often features a low, plunging, or drawstring neckline and short, puffed sleeves (SEE GOWN/CHEMISE).

Pigeon bodice A full-fronted bodice gathered to puff out over the waistline, creating a pigeon-breast effect, popular during the early twentieth century and associated with the Gibson girl style.

Transformation bodice ↑ An ensemble with two or more detachable bodices and a single skirt, used primarily in mid- to late nineteenth-century gowns to transform formal daywear into evening wear.

Bow

A double-looped knot with the ends left free, which can be made of ribbon, string, or cord. Bows are used to fasten garments; as neckwear (SEE NECKWEAR/BOW TIE); to secure bonnets, sashes, and soft belts; and as applied decoration to garments, hats, and shoes.

Braid

An interlaced band created by diagonally crossing strips of a flexible material over one another in a regular pattern. Typically a braid has three strands, but as few as two or more than a dozen may be used. Braids vary in width and may be flat or tubular; lengths of braid can be sewn together to create a fabric. Techniques of hand braiding,

or working a braid on a loom or a handheld, two-pronged tool called a lucet, have a long and culturally diverse history; braids may also be machine made. Lengths of braid are used as braces, belts, ties, and garters as well as for military and fashion decoration (SEE SUSPENDERS; TRIMMING/GALLOON; TRIMMING/GIMP; TRIMMING/RICKRACK; TRIMMING/SOUTACHE).

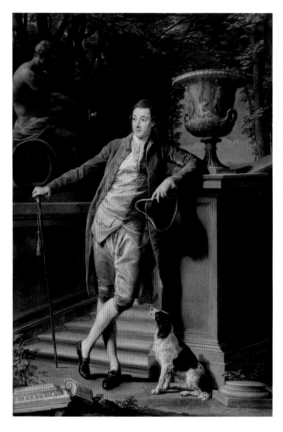

Pompeo Batoni (Italian, 1708–1787), *Portrait of John Talbot, Later 1st Earl of Talbot*, 1773. Oil on canvas, 275.6 × 183.5 cm (108 ½ × 72 ¼ in.). Los Angeles, J. Paul Getty Museum, 78.PA.211

Slim-fitting breeches, fastened just below the knee, were worn by upper-class European men throughout the eighteenth century. These apricot silk breeches are part of an informal suit, appropriate for daytime leisure activities.

Breeches

A bifurcated garment covering the lower body from the waist to just below the knees, with origins in the *braies*, a two-legged garment worn by men as an undergarment and for labor in medieval Celtic and Germanic cultures. Early versions were loose, sometimes in two parts, and tied at the waist. The term "breeches" emerged in the later medieval era designating a garment for an adult male; "breeching" a boy indicated the moment he traded genderless infant dress for men's clothing. Also called the colloquial "britches," breeches worn through the eighteenth century varied in shape, fit, and design, but ended at the knee or just below, and finished with a cuff, band, or lacing. The lower leg was covered by hose. They were replaced by full-length TROUSERS in the nineteenth century, but forms of breeches survive in court costume, formal evening dress, livery, and sports such as riding, golfing, and hunting.

Petticoat breeches Very full-cut breeches, with pleating or gathering at the waistband, often trimmed with ribbons, lace, or a flounce at the knee, worn as court costume in the seventeenth century.

Slops Loose-fitting pants ending below the knee to below mid-calf, associated with mariners from the seventeenth to the early nineteenth century. The hem is typically left wide, but can be cuffed or gathered in.

Trunk hose → A very full, puffy garment, ending mid-thigh, worn in European courts from the later sixteenth to the early seventeenth century. The legs were often padded and/or decorated with embroidery, ribbons, panels, or SLASHING. The waistband could be laced to the lower edge of the doublet (SEE JACKET/DOUBLET), and the front ornamented with a CODPIECE.

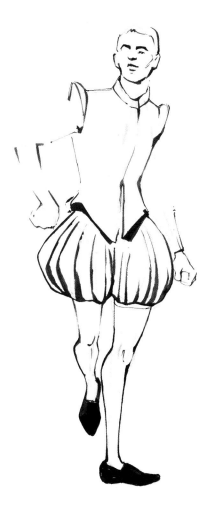

Burqa

A modesty garment worn by women in Islamic societies to conceal them from men other than family members. This full-body veil is secured with a quilted cap, and the multiple yards of fabric are gathered or pleated into the cap rim and flow over the body. A crocheted insert facilitates the wearer's vision, and the waist-length front panel leaves her hands free. Made of lightweight fabric—cotton, silk, rayon—in a subdued color, the burqa renders the wearer anonymous (SEE VEIL).

Bustle

Fullness created at the back of a garment to emphasize and increase the curve below the small of the back. The term also refers to the element that creates the silhouette. With many variations in form and construction, depending on the desired shape

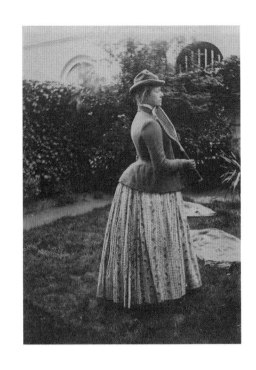

Fernand Khnopff (Belgian, 1858–1921), *Woman with a Tennis Racquet, Study for "Memories,"* ca. 1889. Gelatin silver print, 16.6 × 11.7 cm (6 9/16 × 4 5/8 in.). Los Angeles, J. Paul Getty Museum, 2004.990.2

A light metal frame, tied to the waist beneath the outer skirt, supports this bustle. The high, rounded contour and lack of embellishment indicate that this is a sports costume, just right for a game of tennis.

and style, bustles can be made of a framework of wire mesh, quilted padding, a shaped fabric roll stuffed with horsehair or textile scraps, or carved cork or another light material. Bustles may lie beneath the skirt, or on the outside of a garment as an ornamental feature in the form of ruffles, loops, bows, or puffs. A bustle may also be formed by drawing fabric from the front and sides of the skirt with tapes, arranged and secured to create a fullness at the posterior that drapes down the back. The most extreme form was the shelf-like tournure seen in the early 1870s and early 1880s, particularly in France (SEE SUPPORT).

Button

A small object—usually a disk, dome, or ball—sewn to a garment to be inserted into a BUTTONHOLE. Its origins as an ornament reach as far back as 2000 BCE, but the emergence of the buttonhole during the Middle Ages gave the button a function without diminishing its decorative aspect. Buttons can be made of wood, horn, metal, knotted thread, or mounted precious or semiprecious stones, with plastics most common today. Buttons usually attach to the fabric via thread passed through holes (usually two or four) or through a shank (a metal, thread, or leather loop on the button's underside) (SEE FASTENINGS AND CLOSURES).

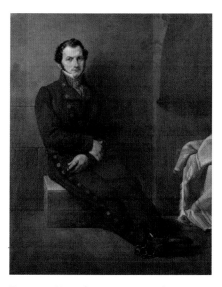

Francesco Hayez (Italian, 1791–1882), *Portrait of Colonel Francesco Teodoro Arese Lucini in Prison*, 1828. Oil on canvas, 151 × 116 cm (59¼ × 45½ in.). Florence, Italy, Uffizi Galleries

The buttons along the colonel's trouser seams are decorative, but those aligned on his jacket create a double-breasted closure. Only the shackles around his ankles indicate his imprisonment for participation in Risorgimento uprisings.

Covered button A dome, disk, or ball that is covered with fabric and secured on the underside with a metal base and attached with a shank; particularly used in fine tailoring and dressmaking.

Cuff button A small button used on a cuff instead of a cuff link, traditionally made of mother-of-pearl.

Flat button The most common form, essentially a disk with two or four holes and often a ring around the rim. To attach, thread is passed through the holes and fabric in an alternating pattern, forming a bar or a cross on the surface of the button.

Shank button A button with a metal, thread, or leather loop on its underside used to attach it to a garment, allowing ease between the joined parts of the garment.

Toggle A rod-shaped button— generally of wood—attached to

a flexible loop. Used in pairs, the body of one toggle is pulled through the loop of the other (which may or may not also have a rod) to loosely secure the opening in a garment, usually a coat or jacket.

Buttonhole

A reinforced slit in a garment created to hold and secure a BUTTON.

Bound buttonhole In which the ends of the slit are widened, and the whole of the slit is finished with a facing that is pulled to the inside to create a clean slot on the outside. Slim strips of folded cloth are then attached to the facing so that they create a pair of lips around the slot.

Loops Cord loops placed along one edge of an opening—usually closely spaced, even forming a continuous line—holding a corresponding line of round buttons along the other.

Machine-made buttonhole Made by attaching a buttonhole presser foot to a sewing machine to position tightly spaced, zigzag stitches around the raw edges of the slit.

Worked buttonhole A handmade buttonhole using tightly spaced blanket or overcast stitching to finish the raw edges. The corners are secured with a tack or a fan pattern of stitches (SEE STITCH/BLANKET STITCH; STITCH/OVERCAST STITCH).

Caftan (kaftan)

A loose, full-length garment worn by men and women throughout the Middle East and North Africa. With origins as a man's garment in the ancient cultures of Meso-potamia, the versatile caftan was widely adopted in subsequent centuries through-out the Byzantine and Ottoman Empires, and then in Eastern Europe and Russia, particularly as clerical and court wear. Versatile, with robe-like lines, a caftan may have long or short sleeves; be made of cotton, linen, or silk; open at the front or at the side; feature button or tie closures; and/or have a hood. By the 1700s, women adopted caftans in the Middle East, and in the mid- to later twentieth century they were appropriated in the West as fashionable leisure wear. They are currently regarded as traditional dress in Arabic Middle Eastern nations and regions with dominant Islamic populations.

Dishdasha The ankle-length men's robe worn across the Arabian Peninsula, also known as a *thoub*. It usually features long sleeves, a front buttoned opening at the sternum, and a round neckline at the base of the neck, and is worn over an *izaar*, a length of cloth wrapped around the legs and fastened at the waist. It is com-monly recognizable in white, but traditionally the color responds to the season.

Djellaba A wide-cut hooded caftan with long sleeves, often made of striped or neutral toned linen, worn in Morocco and other regions in North Africa.

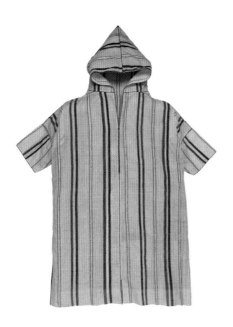

Djellaba, Morocco or Algeria, early twentieth century. Wool, silk. New York, Metropolitan Museum of Art, 1941, C.I.41.110.97, gift of Kate Fowler Merle-Smith

The djellaba combines ease and practicality in its capacious cut and protective hood. While the fabric may vary, the weave is always light, as it is to be worn over other garments in sun or wind.

Kapote (bekishe) A Yiddish term for "caftan" that designates the gabardine overcoat worn by traditional Orthodox Jewish men, reflecting Eastern European origins. The term may derive from the Spanish word *capote* (cloak), with roots in the Ladino (Judeo-Spanish) language and Sephardic culture.

Cage crinoline

An undergarment of graduated hoops that are encased in fabric tubes and connected by vertical tapes, used from the mid-1850s to the early 1870s to shape the overskirt of a gown. Patented in 1856, the cage offered a light, buoyant alternative to the layers of horsehair CRINOLINES used to create the full silhouette favored in the 1840s and early 1850s. The HOOPS were made of cane, whalebone (baleen), or steel; the last of which became the most affordable and practical form. A partial ring was used for the top hoop to allow the wearer to step in and pull the cage up to the waist, which was secured with a firmly buckled band. The size and silhouette of the hoop varied, from the dome of the 1850s to the flattened front favored in the mid- to late 1860s (SEE UNDERGARMENTS/ PETTICOAT).

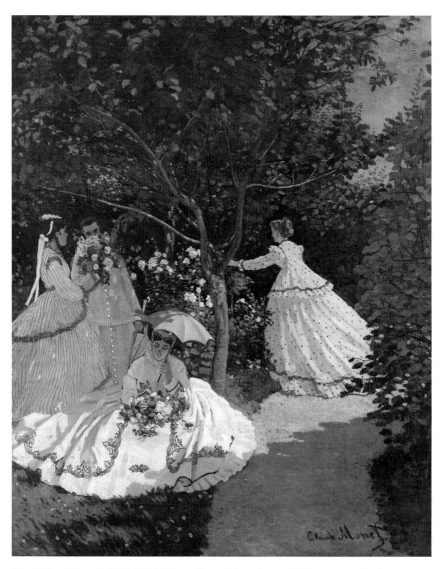

Claude Monet (French, 1840–1926), *Women in a Garden*, ca. 1866. Oil on canvas, 255 × 205 cm (100⅜ × 80¹¹⁄₁₆ in.). Paris, Musée d'Orsay, RMN RF2773

These buoyant skirts are supported by frames of graduated hoops joined by cloth tapes. As an understructure, the cage crinoline was far lighter and more comfortable than layers of restricting petticoats.

Cape

An outer garment without sleeves that covers the upper body from the shoulders to anywhere from the waist to below the knees. The essential feature of cape design is the circular cut; it may be a full circle, a half circle, or sewn segments. Most capes have slits for the arms; they may be lined, hooded, collared, or collarless, with or without a fastening at the front opening. Simple but versatile, with a minimum of sewn elements, versions can be found throughout history and across the globe.

Cloak (*ahu'ula*), Hawaiian, before 1778.
Bird feathers and olona vine fiber.
London, British Museum, Oc,HAW.133

Made for a chief and worn on ceremonial occasions, this winglike cloak invokes feathered deities. The practice of collecting the feathers and sewing them onto a vine netting was traditionally passed down through generations of women.

Burnoose A three-quarter-length woolen cape with North African origins, featuring a pointed hood or back-pointed collar that simulates a hood, often finished with a tassel.

Capelet A short cape-like element ornamenting a coat, jacket, or dress; sometimes detachable.

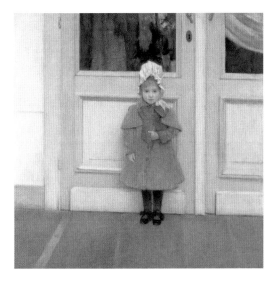

Fernand Khnopff (Belgian, 1858–1921), *Jeanne Kéfer*, 1885. Oil on canvas, 80 × 80 cm (31½ × 31½ in.). Los Angeles, J. Paul Getty Museum, 97.PA.35

The capelet over the shoulders of this girl's winter coat derives from the caped coats worn by coachmen to ward off the cold. Scaled down to a child's size, the feature adds decorative charm as well as warmth.

Cope A semicircular clerical garment, often richly embroidered, fastened across the chest with a clasp or a band. Copes are part of Roman Catholic and Lutheran vestments.

Inverness A long, substantial woolen cape worn by men, usually over a coat for additional warmth and protection from inclement weather.

Pelerine A short women's cape that covers the shoulders. Most popular in mid-nineteenth-century Europe, pelerines were worn as decorative additions over a BODICE, often resembling a very large collar or bertha (SEE COLLAR/BERTHA) that extends over the shoulders. Sometimes featuring elongated front points ending in trim or tassels that can tie across the body to the back, pelerines were often made of luxury fabrics such as fine cotton, lace, velvet, or fur.

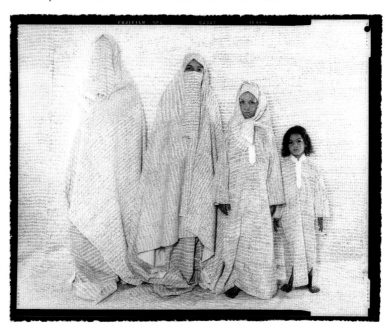

Lalla Essaydi (Moroccan, b. 1956), *Converging Territories #30*, 2004. Chromogenic print, 84.8 × 103.4 × 3.8 cm (33⅜ × 40¹¹⁄₁₆ × 1½ in.). Washington, DC, National Gallery of Art, Corcoran Collection, 2015.19.5242, gift of Julia J. Norrell in honor of Nell Hennessy

Islamic modesty garments for women vary according to age, region, sect, marital status, and preference. The chadors worn by the two women on the left swath the body over other garments and may be combined with a face veil and headscarf. The henna script on the girls' faces is a feature of Essaydi's art, countering the traditional assumption that calligraphy is a masculine practice.

Chador

A full-body outer cloak worn by women for modesty in Islamic societies. The length varies, as does the fabric and color, and the chador may cover from head to toe or be worn with a headscarf. Cut as a large semicircle, it has no hand openings, buttons, or ties; it is pulled over the head and held closed. The enveloping shape reflects the Persian root of the term that designates a large cloth, tent, or sheet (SEE VEIL).

Changshan

The long shirt worn by men during China's Qing dynasty (1644–1912), introduced by Manchu rulers with the fall of the Ming dynasty. Covering the body from shoulder to wrist and ankle, the *changshan* has a wide, flat silhouette with narrow sleeves and single or double side slits, opens at the neck with a right-side overlap, and features a stand-up collar. It may be worn with trousers or an underskirt and a riding jacket (*magua*). Han men serving the court were required to wear the *changshan*, and eventually it replaced HANFU throughout China (SEE ROBE/*CHANGPAO*).

Chemise

A slim, straight-cut garment that skims the body. Prior to the fourteenth century, a linen chemise with sleeves was commonly worn in Europe as an undergarment to provide warmth, for modesty, or to protect the outer garments from perspiration. After that, some variation of the word "shirt"—as well as a shorter length—differentiated a man's garment from a woman's, which was also called a smock. In the late eighteenth century, the word was revived to describe a simple, high-waisted dress (SEE GOWN/CHEMISE), and in the nineteenth century, a short version of the chemise or chemisette was worn under the bodice and corset. Designed with very short sleeves or sleeveless, a chemisette was often trimmed with lace, embroidery, tucks, or buttons meant to be seen when worn with a décolleté neckline (SEE NECKLINE/DÉCOLLETÉ).

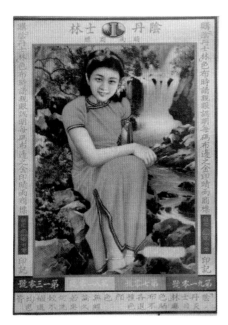

Poster advertising soap, 1930s.

The short-sleeved, close-fitted cheongsam of the 1930s merged traditional Chinese style lines with Western glamour and fit. The slim silhouette projected a modern image for Chinese women, especially in advertising and film.

Cheongsam (*qipao*)

A slim-fitted dress that embodied the vogue for westernization in China from 1912 to 1949. The original 1920s silhouette was loose, but over the decades the gown tightened to display the body. Hemlines vary, as does sleeve length. Standard features include a standing collar, a flap fastening (lapping to the right) that runs from the collarbone to under the right sleeve and then down the side, and a side slit. After the Revolution, the cheongsam was worn by women living outside mainland China, often as a statement of protest against the People's Republic. Traditionally cheongsam are made of silk, embellished with embroidery and silk knot buttons, and—in red—regarded as bridal wear.

Cloak

A loose outer garment without sleeves or arm slits, extending from the shoulders to any point from below the hips

to the ankles. The design is based on a rectangular cut of cloth, with minimal sewn features. A versatile garment, with variations found throughout history and around the globe, a cloak may be draped around the body, fastened, belted, or left open; it may have a hood or pockets.

Chlamys An oblong of fabric, as much as six feet long and three feet wide, wrapped around the body and fastened on one shoulder with a pin, worn around the ancient Mediterranean and throughout Europe in the early Middle Ages.

Domino A voluminous black hooded cloak, derived from a monk's hooded robe, worn during the eighteenth and nineteenth centuries in Europe as part of evening or masquerade wear (SEE MASK).

Mantle A long, loose oblong or half-circle designed to rest over the shoulders. In many cultures it is worn as a mark of status, especially royalty, and made of luxurious or symbolic materials, including feathers or fur. The term covers a very wide range of social, practical, and ceremonial garments.

Opera cloak An ankle-length luxury garment worn over evening clothes, originally black and worn by men in the later nineteenth century. The women's opera cloaks that emerged in the early twentieth century were highly inventive in cut (even featuring sleeves), ornamentation, and fabric (especially velvet, silk, and brocades), so as to attract attention when one arrives at exclusive events.

Poncho A square or oblong blanket or blanket-like cut of fabric with a slit in the center for the head. With origins in the ancient Americas, ponchos have proved an enduring and versatile garment. Modern ponchos are often made of waterproof textiles and worn for weather protection.

Coat

A garment designed to be worn over a full set of clothing, particularly for warmth or weather protection outdoors. Usually long-sleeved and cut larger and longer than the garments worn beneath, it may fasten with buttons, zippers, or a belt, or be worn open. The tailored coat replaced the cloak as favored outerwear for men in the later seventeenth century; coats for women retained a cloak-like silhouette when voluminous styles were in fashion. Coats often take their name from their function (topcoat, overcoat, evening coat) or the weather (winter coat, raincoat). Many share style lines with jackets and, depending upon length, a short coat may also be called a jacket (SEE JACKET; KIMONO/UCHIKAKE; ROBE).

Box coat A warm coat with straight, simple style lines and a single or double cape, derived from a coachman's coat.

Cassock A full-length overcoat with a cape-like collar worn by women for informal and sporting activities between the sixteenth and nineteenth centuries; also a clerical robe.

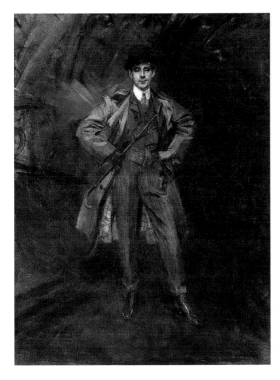

Giovanni Boldini (Italian, 1842–1931), *Portrait of Georges Coursat, called Sem*, 1902. Oil on canvas, 91.5 × 73 cm (36 × 28¾ in.). Paris, Musée des Arts Décoratifs, 37353

An overcoat was once a staple of any Western urban man's wardrobe. Society caricaturist "Sem" teams a military-style trench coat with other fashion trends: creased and cuffed trousers, a short waistcoat, and a tilted bowler hat.

Chesterfield A slim, straight-cut overcoat—single or double breasted—trimmed with a velvet collar. It was named in the 1840s for George Stanhope, the Sixth Earl of Chesterfield, who is credited with starting the trend.

Clutch coat A coat designed without fastening, intended to be manually held closed. The cocoon coat of the early twentieth century, padded to create a rounded shape in the upper back, is a distinctive form of the style.

Duster A very loose cotton coat, in tan or brown, with a spread collar and buttons to the neck, worn to protect garments from soiling, especially when motoring in the early decades of the twentieth century.

Mackintosh A waterproof coat, originally made of a type of India rubber patented by Charles Macintosh in 1823; now a general British term for raincoat.

Paletot A common, unspecific term for "overcoat" in Europe in the first half of the nineteenth century. By mid-century it designated a full, seamless woman's coat worn over a gown with a hoop skirt.

Parka A warm, water-repellent garment with a hood, often lined with fur (or a synthetic alternative) and closed with a zipper. The style, as well as the term, is adapted from the highly protective skin and fur garments worn by Indigenous people of the northern polar regions.

45

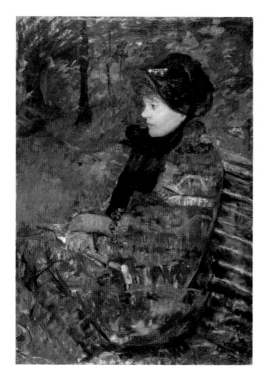

Mary Cassatt (American, 1844–1926), *Autumn (Portrait of Lydia Cassatt)*, 1880. Oil on canvas, 93 × 65 cm (36⅝ × 25½ in.). Paris, Musée du Petit Palais, Musée des Beaux-Arts de la Ville de Paris, PPP706

The lively pattern and vivid colors suggest that this sitter's garment is a visite made from an imported shawl. Once it fell out of fashion, this expensive accessory was often repurposed into a coat or mantle.

Pelisse Originating in the Middle Ages as a fur-trimmed cloak, and in the nineteenth century used to designate a woman's cloak-like coat—often fur trimmed, hooded, and with slits instead of sleeves.

Prince Albert An elongated frock coat with a velvet collar worn as a topcoat, named for Albert, Prince Consort to Queen Victoria of Great Britain, who favored the style (SEE JACKET/FROCK COAT).

Redingote An overcoat hemmed at the waist in the front and with long tails at the back, styled to facilitate riding. It features wide, open lapels and is usually double breasted (SEE RIDING HABIT).

Surcoat A long, TUNIC-like overgarment worn by men in the mid to late European Middle Ages. It could be sleeveless, have mid-length sleeves, or feature tight, long sleeves. The length varied from knee to above the ankle, and the sides were split to facilitate movement.

Trench coat A double-breasted, belted overcoat made out of waterproof cotton gabardine patented by the British men's outfitter Thomas Burberry in 1888. The coat, as worn by officers serving in World War I, featured wide lapels, slanted front pockets over the hips, a buttoned yoke in the front and back, and epaulettes. It has since become a gender-neutral wardrobe staple.

Visite A colorful woman's coat made of repurposed cashmere or paisley shawls worn in the 1870s and 1880s, when the shawl fell out of fashion.

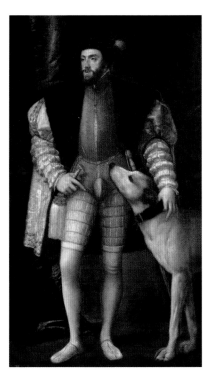

Titian (Tiziano Vercelli) (Italian, ca. 1487–1576), *Emperor Charles V with a Dog*, 1533. Oil on canvas, 194 × 112.7 cm (76⅜ × 44⅜ in.). Madrid, Museo Nacional del Prado, P000409

Originally designed to hide the front join of breeches or leggings, the codpiece quickly became an ornament in aristocratic male attire. Here, it is prominently displayed even though the length of the outer garment, if closed, would have covered the separation.

Codpiece

A triangular panel fastened at the crotch of trunk hose (SEE BREECHES/TRUNK HOSE) or leggings. Laced or pinned in place, the codpiece connected the separate legs of men's garments—providing modesty while facilitating access for bodily function—from the thirteenth through the seventeenth centuries. The term "cod" was slang for male genitalia. During the fifteenth century, when short doublets (SEE JACKET/DOUBLET) were in fashion, the codpiece was decorated with embroidery, and in the sixteenth century, shaping and padding added even more swagger. It was also used to carry small items such as coins or medicine. The codpiece went out of fashion with the rise of BREECHES and finely knitted hose (SEE LEGGINGS).

Collar

A finishing element encircling the neck that is attached to or extends from the neckline of a garment; collars may be sewn to the garment or detachable, and either positioned directly at the neckline or raised on a band. Their origin seems to have been practical—a band at the neck that can be removed for washing or readily replaced. As a style feature, collars take any number of forms and can be made of a contrasting fabric or texture to add decorative flair. The term also applies to a broad, necklace-like element that surrounds the neck and lies flat on the chest and shoulders (SEE NECKLINE; NECKWEAR; RUFF).

Band collar A strip of fabric that encircles the base of the neck, usually fastening at the front. Plain white bands are worn by members of the Protestant clergy. Bands also are used to attach collars to the neckline, especially on shirts.

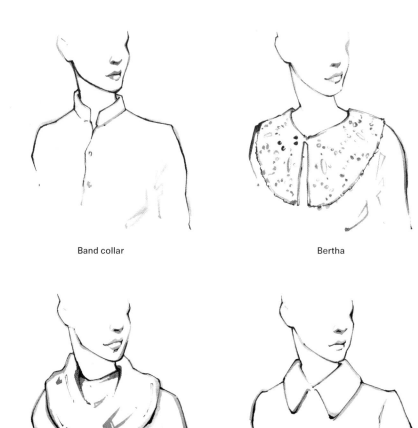

Band collar

Bertha

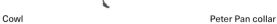

Cowl

Peter Pan collar

Shawl collar

Bertha A cape-like collar that attaches directly to the neckline and covers the back and shoulders of a BODICE; may be split in the front.

Bow collar A flat, standing band collar with extended ends that are looped or tied in a bow.

Cavalier collar A broad collar that lies flat over the shoulders, often made of or trimmed with lace; also called a falling collar.

Convertible collar A rolled shirt collar that can be worn spread open, forming notched lapels, or closed with a button fastening.

Cowl A draped collar, often cut on the bias, that encircles the neck like a monk's cowl.

Peter Pan collar A small, rounded collar, split at the front. Usually a white accent, it began as a detachable element for children's garments and was subsequently named for the character in J. M. Barrie's 1904 fairy tale.

Revere collar A collar with lapels that are formed by folding back the top edge of the neckline opening to expose the facing or lining. Adopted from the REVERS of a jacket or coat.

Rolled collar A shirt collar without a band. The shape is cut and sewn as part of the neckline and rolls back to form the collar.

Shawl collar A rounded collar, seamed at the back, that follows the open neckline of the garment.

Shirt collar A pointed collar with spread, reinforced points, raised on a band and fastened with a button or a stud. There are a wide variety of profiles, with the rise of the band and the spread of the points reflecting changing fashion. In the twentieth century, color became a symbol to refer to types of work: a white collar for office and other professional positions, blue for manual labor, and pink for secretarial work done by women.

Standing collar (Mandarin collar, Nehru collar) A band collar that rises up the neck. It may fully encircle the neck or not quite. The closure may be at the front, back, or side, and can fasten with decorative elements (buttons or frogs) or hidden hooks and eyes.

Turtleneck (polo neck) A high band, usually of a knit fabric that is rolled back on itself. A mock turtleneck is a flat (as opposed to rolled over) encircling band that rises up out of a crew neckline.

Wing collar A shirt collar with a high band that has attached, bent-back points called wings; often stiffly starched.

49

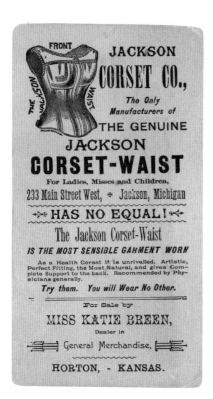

Jackson Corset Company (founded 1884), Jackson Corset-Waist trade card, 1884–97. Topeka, Kansas Historical Society, 70.163.10

The corset featured on this advertising card creates the fashionable silhouette of a high bustline and diminutive waist. Promotional copy on the back touts it as healthful, natural, and "recommended by physicians."

Corset

A closely fitted, often rigid support garment worn by women, and sometimes men and children, to support the body from under the bust to the waist or below. The term, which replaced "stays" (used between the sixteenth and nineteenth centuries), derives from a diminutive of the Old French *cors* (body). Over the centuries, corsets have been used to support women's breasts, taper the waist, smooth the hips, and flatten the stomach in conformance with the prevailing silhouette; they have also been promoted as health aids that support the inner organs or improve posture. Usually fastened by hooks and eyes in the front, corsets are tightened to the desired constriction via back lacing. They have been worn as undergarments, over the bodice, and, recently, as a top (SEE BODICE/*CUIRASSE*; SUPPORT/BONING; UNDERGARMENTS).

Busk A strip of strong, flexible material (whalebone, some woods, horn) inserted in the center front of the corset to add stability and often decorated with intimate significance.

Bustier A shaping garment combining the functions of a corset and a brassiere (SEE UNDERGARMENTS/BRASSIERE). It may be strapless and decorated to be seen

either above a deep neckline or under the open front of a jacket. In the mid-twentieth century, a variant called a merry widow shaped the waist and hips to an hourglass silhouette and had suspenders to which one would fasten stockings.

Corset cover A light garment, with straps or sleeveless, worn between a corset and a gown to give a smooth appearance, and often trimmed like a camisole to be seen above the neckline of the garment (SEE UNDERGARMENTS/CAMISOLE).

S-bend A long corset, worn in the very late nineteenth century and the first decade of the twentieth, shaped to push the chest forward and the hips back for the fashionable S-curve, mono-bosom silhouette. It was worn with a spoon-shaped busk that supported the abdomen, sometimes called a swan's bill (SEE CORSET/BUSK).

Stays A two-piece corset, reinforced with iron or whalebone, with laces front and back worn in Europe between the sixteenth and the nineteenth century. Short stays supported only the breasts and rib cage.

Swiss waist A corset worn over the bodice, scooped under the breasts, usually with straps and laced in the front rather than the back. It was part of a traditional woman's ensemble, as well as agricultural wear, across Europe (SEE SKIRT/DIRNDL).

Waist cincher A short corset—from below the rib cage to over the hips—that draws in the waist to create an hourglass silhouette. It has been revived several times since the late twentieth century to create an extreme silhouette.

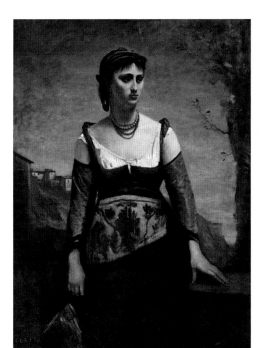

51

Jean-Baptiste-Camille Corot (French, 1796–1875), *Agostina*, 1866. Oil on canvas, 132.4 × 97.6 cm (52⅛ × 38⁷⁄₁₆ in.). Washington, DC, National Gallery of Art, Chester Dale Collection, 1963.10.108

The Swiss waist emphasizes the torso but does not restrict the waistline. Combined here with a simple camisole, sleeves, and an embroidered apron, the loosely laced garment completes a romanticized version of a peasant woman's ensemble.

Coveralls

A full-body protective garment with long legs and long sleeves. Coveralls are worn over clothing, particularly for work that involves exposure to dirt or hazardous materials, including construction, farming, factory work, logging, mechanics, mining, and waste collection. The front opening closes with snaps or zippers, and the sleeves can end with a cuff or a simple hem. Coveralls have pockets, and sometimes loops, designed to hold the tools for a specific type of work, such as house painting or carpentry.

Boilersuit A twentieth-century term for the garment worn by British munitions workers between the World Wars.

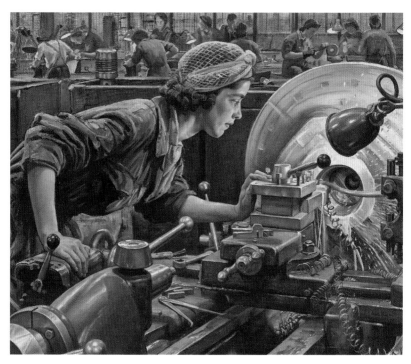

Laura Knight (British, 1877–1970), *Ruby Loftus Screwing a Breech-Ring*, 1943. Oil on canvas, 86.3 × 101.9 cm (34 × 40⅛ in.). London, Imperial War Museum, Art.IWM ART LD 2850

Ruby Loftus's work attire—a boilersuit and a hairnet—was the uniform of the female World War II munitions worker. Her practical garments not only protected her skin and clothing; they symbolized the seriousness of women's contributions to the war effort.

Jumpsuit A full-body-cover garment that may be worn without clothing beneath, for work or for fashion.

Onesie Originally an all-purpose one-piece garment for infants with a snap opening along the legs and crotch, now made in adult sizes (of soft material, with a front opening) for relaxing and sleeping.

Overalls A cover garment with a bib front, secured by buckled shoulder straps that cross in the back. It features a waistband secured with a buckle and slant pockets at the hips, and may have a pocket on the bib. Overalls are usually worn over a shirt or T-shirt, while the lower garment functions as trousers. In the United States originally an agricultural garment made of denim, overalls have been adapted for other professions as well as for fashion, with varying leg lengths (from ankle to thigh), and for toddlers.

Crinoline

Named for *crin* (a French term for "horsehair"), a stiff textile woven with a horse-hair weft and a linen or cotton warp used for underskirts to create a voluminous silhouette. Such underskirts were heavy and hard to clean, leading to the invention of the CAGE CRINOLINE. Since the mid-nineteenth century the term has referred to an underskirt made of fabric stiffened with sizing, gelatin, starch, or wire (SEE UNDERGARMENTS/PETTICOAT).

Cuff

A finishing element for the bottom of the sleeve. It may be sewn on or cut as part of the sleeve; may extend and reinforce the opening for the hand; and may or may not fasten. Cuffs developed to protect the ends of sleeves, as a detachable (for cleaning) or readily replaceable element, but they were also decorative, adding shape, contrast, and luxurious embellishment such as lace.

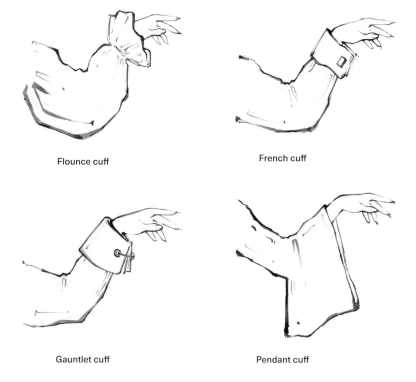

Flounce cuff

French cuff

Gauntlet cuff

Pendant cuff

The term refers as well to the upper part of the glove that extends beyond the wrist; an upper addition to a boot; and the turned-up finishing on a trouser hem (SEE SHIRT; SLEEVE; TROUSERS).

Band cuff A separate strip of fabric attached to the end of a sleeve for a clean finish. It may gather in excess fabric or serve as a casing for elastic or a drawstring.

Button cuff (barrel cuff) A sewn-on shirt cuff that closes with buttonholes and buttons. A similar cuff with buttonholes on both sides is called a link cuff.

Flounce cuff A decorative ruffle made of lace or a delicate fabric, sewn to extend over the wrist and hand from the clean-finished hem of the sleeve.

French cuff A large, sewn-on shirt cuff with buttonholes on each end that doubles back on itself to align the buttonholes, which are then fastened with cuff links or silk knots.

Gauntlet cuff An extended, flared sleeve end that is clean finished and turned back over the wrist to resemble the cuff of a glove.

Pendant cuff Cut as part of the sleeve or an attached extension that creates a hanging profile from the wrist to any point on the forearm.

Rolled cuff A sleeve end rolled back on itself to expose the arm anywhere from the middle of the forearm to above the elbow. A rolled sleeve is informal; it may be created with any shirtsleeve or designed as part of the garment.

Culottes

Originally a French term, traced to the late sixteenth century, for elaborate breeches (SEE BREECHES/PETTICOAT BREECHES), and now referring to a bifurcated skirt. The word acquired political significance during the French Revolution (1789–99), when one of the most radical revolutionary groups styled themselves *sans-culottes* (without breeches), rejecting elite society through symbolic dress. These advocates of direct democracy adopted *pantalons* (long, full trousers worn by workmen) in contrast to aristocratic silk breeches. Modern culottes resemble a skirt more than trousers, and they became popular in the twentieth century as women's leisure and athletic wear. In the twenty-first century, the garment is seen as gender neutral.

Dagging

Cutting hems, sleeves, or other edge lines of a garment into repeated decorative shapes; also described as cutwork or jagging. Particularly seen in European dress in the fourteenth and fifteenth centuries, dagging takes many ornamental forms, including leaves, notches, points, scallops, and tabs.

Jan van Eyck (Flemish, ca. 1390–1441), *The Arnolfini Portrait*, 1434. Oil on oak panel, 82.2 × 60 cm (32⅜ × 23⅝ in.). London, National Gallery, NG186

The bag sleeves of the woman's houppelande (voluminous outer gown) are finished with dagging and edged with fur, likely miniver, made of the pale hairs groomed from a squirrel's belly.

Dart

A tuck folded on the inside of a garment and sewn on an angle to end in a point. Darts shape flat fabric to the body's contours and are generally used at the bust, at the neckline, or at the waistline to accommodate the curve of the hips. Double-pointed darts (diamond or fisheye) and darts running from the waistline to below the bustline (French) are used to shape the torso; curved darts provide an even closer fit.

Drape

The fall of soft folds of fabric when a piece is held at one or both ends. Draping a bodice, skirt, gown, or cape creates an easy flow along the natural lines of the body (SEE CAPE; SARI; TOGA). Drapes may also be decorative elements applied to a garment, as with a swag, a length of fabric fastened on either end so that the center droops into natural folds. Draping is the oldest means of fabricating garments, in which an uncut length is arranged and secured on the body with minimal pinning, tucking, or knotting. In the design process, draping is the experimental stage when fabric is arranged and pinned in place on a dress form or directly on the body prior to pattern cutting.

Embroidery

A range of needlework techniques used to embellish fabric. The embroiderer's repertoire includes a wide variety of stitches, including many used in construction (running stitch, backstitch, blanket stitch; SEE STITCH), as well as stitches used purely for ornamental effect. Almost any thread can be used, with silk, cotton, and metallic the most popular. Evidence of embroidery has been traced to many ancient cultures, and global traditions are varied and enduring. Embroidery may be located on any part of the garment, with placement and pattern often reflecting traditional practices. Designs may include beadwork, sequins, and encased cords to add dimensionality.

Diego Rivera (Mexican, 1886–1957), *La Bordadora (The Embroiderer)*, 1928. Oil on canvas, 79.2 × 99.2 cm (31 3/16 × 39 1/16 in.). Houston, Museum of Fine Arts, 2022.45, museum purchase funded by the Caroline Wiess Law Accessions Endowment Fund

A wooden frame holds the fabric taut as this woman works a traditional Tehuantepec design in vibrant-hued threads. The double floral border of the embroidered panel suggests that it will be used as a shawl.

Black work Elaborate floral and foliate patterns worked in black silk on linen, seen in European court dress in the sixteenth century, often embellishing women's bodices and sleeves. It was associated with women's dress in Tudor England (1485–1603) as "Spanish black work" when Catherine of Aragon became the first wife of Henry VIII. "Scarlet work" is similar, using vivid red thread.

White work A delicate technique using white thread on white fabric for fine shirts and blouses, intimate apparel, and infants' layettes (a newborn's ensemble comprised sleepwear, underwear, caps, booties, and blankets). As well as a variety of stitches, decorative openwork patterns can be incorporated via drawn thread (pulling a warp or weft thread out of the fabric and fastening it to other such threads with small, secure stitches) (SEE FAGGOTING).

Epaulette

A band of metal or fabric applied to the shoulder of a garment to signify rank or as decoration. Derived in the seventeenth century from the French diminutive for "shoulder" (*épaule*), the term first referred to bunches of ribbons worn on military jackets to support a shoulder belt. By the eighteenth century, a light metal plate or fabric band replaced the ribbons, and placement on the right or left shoulder indicated rank. Later in the century a "counter-epaulette" was added to the opposite shoulder. Stiffened cloth, often embellished with metallic thread and fringe, replaced metal plates, with the outer end sewn into the shoulder seam and the inner end buttoned near the collar. Epaulettes have survived in all branches of military dress; they also have been adopted by some civilian organizations and are a distinctive feature of the trench coat (SEE COAT/TRENCH COAT).

Facing

A finishing technique for necklines, armholes, and PLACKETS in which a shaped piece of fabric is sewn to the edge of an opening and turned to the inside to create a clean enclosure and add light support. A line of stitching on the facing near the seam prevents rolling. A facing can also be cut as an extension of the pattern piece or made with a BIAS strip. Facings may be of the same fabric as the garment or cut from LINING material.

Faggoting

A decorative, open net of regularly spaced V-shaped stitching that joins the edges of two pieces of fabric. It is most commonly used at seams. It is also a drawn-thread embroidery technique in which several horizontal threads are removed and the remaining vertical threads are tied in bundles at intervals to create an openwork pattern (SEE EMBROIDERY/WHITE WORK).

Fastenings and closures

Mechanisms to secure functional openings in garments such as coats or shirtfronts, necklines, dress backs, or trouser fronts. They may be hidden, or designed as part of the decoration. The specific term used denotes both the type of closing and the elements necessary to make it work (SEE BUTTON; BUTTONHOLE; LACING; ZIPPER).

Clip A two-part metal fastener with a spring-operated hook on one side that attaches to a ring, eyelet, or slot on the other side.

Double breasted Referring to two vertical lines of buttons on the front of a coat or jacket. Originally a double-breasted garment featured a full overlap and both sets of buttons functioned, with one of the lines having hidden backing buttons on the inside to be inserted into buttonholes on the inner lap. Now, more typically, one line of buttons is functional, and the other decorative. The button lines may begin very widely spaced near the top of the chest (as decorative) and taper toward the waist (to function) or be set parallel (all functional).

Eyelet A small, reinforced hole in a garment through which a cord, lace, or string is passed. Set in a series, eyelets hold the crossings of LACING. The hole can be reinforced with a tight overcast stitch or strengthened with two metal rings that are designed to slot together and be hammered in place. A heavy eyelet is called a grommet.

Fly front A closure of laces, buttons, or a zipper, hidden under a PLACKET. It is commonly associated with skirts and trousers, but can be made for a coat or jacket front.

Frog An ornamental closing made out of twisted cord or braid, with one end having decorative lobes in foliate form and the other a knot or a loop. The knot of one frog is slipped into the loop of the other to create a loose closure, and the edges of the garment meet rather than overlap. Frogs originated in China, where they were known as *pankou* or *huaniu* (flower buttons). The origin of the English term is not known, but it may derive from the Latin *floccus* (flock of wool), or a derogatory term for French soldiers. Around the sixteenth century, frogs were adopted as a decorative feature for European military uniforms and eventually were used on blouses and bodices, as well as coats and dressing gowns.

Hook and eye A small metal hook that catches a metal or thread loop to secure an opening. The metal may be encased in thread.

Snap A two-part metal or plastic fastener—one side with a circular depression and the other with a projection that fits into that depression—that snaps together with a little force. Both disks are sewn inside the garment. Patented in Europe in the 1880s, snaps were first used for easy openings in military uniforms and US Western wear. They are now commonly used on children's garments, especially on the inner legs and crotch of infant wear. Alternate terms include "poppers" and "press studs."

Stud A sturdy form of snap made of metal with a button-like top disk permanently hammered over the upper disk on the outside of the fabric; used for jeans, heavy work wear, and other denim garments.

Eyelet

Fly

Frog

Footwear

An outer covering for the foot. Even when highly decorative, footwear is utilitarian, protecting feet and hose from dirt, damp, and damage. Typically it has a durable sole—with or without a raised heel—and a softer upper part that encloses the foot. It may fasten with straps or laces, or slip on. Footwear is ubiquitous across time and around the globe, with many variants related to use, style, and gender. The two main types are shoes (ending below the ankle) and boots (rising above the ankle), and while they are made in pairs, right and left are not always differentiated (SEE GAITER; LEGGINGS; PUTTEE).

> Chopines Shoes with high platform soles made of covered cork, worn for fashion in European courts in the sixteenth and seventeenth centuries. It was an elite, impractical style, with extreme versions for women featuring soles as thick as eighteen inches.

Manchu woman's shoe (*haupen di*), Chinese, Qing dynasty, late nineteenth or early twentieth century. Silk and wood (?). New York, Metropolitan Museum of Art, 45.108.2, gift of Mrs. Charles Albert Perkins

Foot binding was forbidden to women in the Qing dynasty court. The high, set-back platform of the "flowerpot" *haupen di* forced the wearer to adopt the restricted gait of a Han woman with the traditionally truncated "lotus foot."

> French fall boot A tall leather boot with a wide upper cuff that folds back or is pushed into soft rumples at the knee and/or upper calf.
>
> *Geta* Traditional flat Japanese footwear secured to the foot with a fabric thong, with two or three vertical "teeth" on the underside that raise the sole above the ground. A similar style without teeth is called *zori*; traced to ancient times, *zori* may be secured with thongs or straps. Both styles are worn with *tabi*, socks with a separate sheath for the big toe.
>
> *Haupen di* A platform shoe worn by Manchu women in the Qing dynasty court (1636–1912) that gave the appearance and gait of the so-called lotus

foot (bound foot) of Han women. The platform soles were either *huapenxie* (flowerpot) or *matixie* (horse hoof) in form, and the uppers were made of fine, richly embroidered fabrics.

Jackboot A European man's heavy boot, originally worn for riding and military maneuvers, with square toes, a square block heel, and expanded bucket tops that fold back over the top edge of the boot.

Pair of moccasins, Seneca, New York, ca. 1808. Native-tanned skin and porcupine quill. New York, Metropolitan Museum of Art, 2011, 2011.154.188 a,b, Ralph T. Coe Collection, gift of Ralph T. Coe Foundation for the Arts

Derived from the Algonquian word *makasin* (shoe), "moccasin" covers a wide range of footwear worn by Indigenous North Americans. Distinctive decoration and style lines, such as this cuffed opening, represent traditions of individual regions and peoples.

61

Moccasin A slip-on style derived from Native American traditional footwear in which the sole and the upper are cut of a single piece of treated hide and fitted to the foot with a lace run through a casing or holes around the top edge. It may have a tongue over the upper instep, and be trimmed with beads or fringe.

Patten A raised, wooden-soled overshoe worn outdoors to protect finer footwear. It is attached to the foot with straps over the shoe or boot.

Poulaine A long-toed flat shoe associated with the arrival in England of Anne of Bohemia in the later fourteenth century to marry Richard II. Exaggerated versions, with toes so long that they required stiffening or were fastened to the leg or lower body garments with a fine chain, became popular for men in European courts in the first decades of the fifteenth century. They are also called crakows, in reference to Poland.

Sabot A slip-on shoe carved from wood worn throughout Europe for agricultural work. When backless, it is also called a clog.

Sandal Likely the oldest form of footwear—simply a sole held to the foot with straps. Worn by men and women across eras and cultures, variants reflect purpose and regional preference as well as style.

Spat Short for "spatterdash," a fabric guard fastened over the instep and ankle of footwear to protect from soiling, especially from muddy streets.

Stiletto A high-heeled shoe with a steel-reinforced shank (lower instep) and a very narrow heel to support an exaggerated silhouette, developed between the 1930s and 1950s. Stilettos can rise as high as six inches.

Gaiter

A protective covering for the lower leg and ankle, typically of cloth or leather, used for hiking, riding, inclement weather, and military gear (SEE FOOTWEAR/SPAT; PUTTEE). Gaiters may button or buckle at the side and are sometimes secured with a strap under the foot. Mostly worn by men from the eighteenth through the twentieth century, gaiters gained popularity among European women between the 1820s and the 1840s. Until the mid-twentieth century, gaiters made of cotton, wool, or silk were worn by the clergy of the Church of England. A tube-shaped neck warmer made of soft wool or fleece and pulled over the head is also called a gaiter.

Garter

A band of fabric used to secure a stocking above or below the knee. Prior to the development of the elastic band, patented in 1845 by London rubber manufacturer Stephen Perry, garters were wrapped and tied. Worn by adults and children, those for adults were sometimes richly and seductively embellished with lace and embroidery. In the twentieth century, the elasticized suspender belt replaced garters (SEE UNDERGARMENTS/GARTER BELT). Cross-braced garters are tied above and below the knee with a crossover in between. In the mid-nineteenth century, the marketing of ready-to-wear shirts with a standard arm length led to arm garters worn on the upper arm, over the shirt, to shorten the sleeve.

Gather

To ease fullness by pulling the thread of one or more rows of parallel running stitches to draw the fabric into soft, even folds. The stitches may be hand sewn; if machine sewn, the bobbin thread is pulled to create the gathers. Gathers are most commonly used to accommodate a skirt's fullness at the waist, to fit the top of a sleeve into the ARMSCYE, or to fit the end of a sleeve into a CUFF (SEE SHIRRING).

Glove

Hand coverings with separate sheaths for each finger. The term derives from the Old English *glóf* (palm). Made of such pliable fabrics as leather or stretch knits, gloves may be worn for warmth, fashion, ritual circumstances, hygiene, utility, or decorum. Whether the glove has buttons or not, length is counted in "buttons," with one button slightly longer than an inch. Depicted even in prehistoric cave paintings, hand coverings have a long, global history, but very few ancient examples survive; a pair of linen gloves with articulated fingers found in the tomb of Tutankhamun may be the oldest known. The ancient Romans distinguished *digitalia* (with articulated fingers) from *chirothocae* (only an articulated thumb, resembling a contemporary mitten). Across cultures, gloves have been worn as symbols of status, as symbols of office, and in sacred ceremonies (so as to avoid touching ritual objects directly). Among elites, they have been given as gifts and worn for riding, hunting, and

Amy Sherald (American, b. 1973), *Miss Everything (Unsuppressed Deliverance)*, 2014. Oil on canvas, 138 × 109.5 cm (54 × 43⅛ in.). Private collection, © Amy Sherald. Courtesy the artist and Hauser & Wirth

Through most of the twentieth century, pristine white gloves represented "ladylike" decorum for social gatherings. Here, the oversize teacup and rakishly tilted hat counter etiquette with irony.

hawking. As protective wear, they have a long history in the trades and in agricultural labor. The names reflect length and occasion (bracelet, three-quarters, opera). By the nineteenth century, gloves were a fashionable accessory with an elaborate etiquette, particularly for women: remove gloves when eating, wear while drinking or dancing; wear bracelet over, rings under. Gloves may be fingerless or expose the fingertips for practicality; slashed or open-backed for flexibility, especially for sports; and trimmed in extravagant ways or left plain. Fit is essential for deft movement, leading to such sayings as "fits like a glove" or "hand in glove."

Gauntlet The hand piece of a suit of ARMOR, giving rise to a challenge described as "throw down the gauntlet" and, later, "throw down the glove." The word also describes a fitted glove with a flared cuff over the wrist, an elegant status symbol among European men in the seventeenth century, usually made of fine, pliable leathers such as doeskin, in pale colors.

Mitt A fingerless glove—knit, crocheted, or made of lace—that covers to the wrist or a bit beyond and served as a women's fashion accessory in the eighteenth and nineteenth centuries.

Mitten Made of wool, skins, fur, or knitted yarn with an articulated thumb and a single case for the fingers, worn for warmth.

Godet

A triangular insert, sometimes with a rounded contour, sewn into a slit or between two pieces of fabric to add amplitude to the bottom edge of a skirt, jacket, or glove cuff. Godets add a flared contour to a garment hem, either spreading outward to add dimension or pressed to lie flat under the garment like PLEATS.

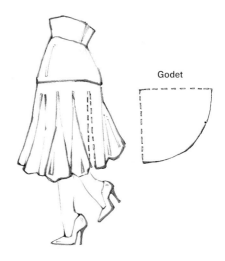

Godet

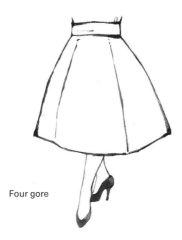

Eight gore

Gore

An elongated panel, wider at the bottom than the top. When identical gores are sewn together, they can create a fitted skirt or dress without need for further shaping. Gored skirts typically feature four to six panels, but can be created with as many as twenty-four. Although often used interchangeably with the term "GODET," a gore has a trapezoidal shape, while a godet is essentially a triangle.

Four gore

Ten gore

Lupita Nyong'o arriving at the 86th Annual Academy Awards at the Dolby Theater, Los Angeles, 2014.

This pleated silk Prada gown echoes the flow and style lines of a classical Greek chiton. To honor Lupita Nyong'o's homeland, the designer used a delicate color she called "Nairobi blue."

Gown (dress)

A garment covering the body from the shoulders to anywhere from the thighs to below the ankles. Variants of gowns can be found across eras and cultures, with a wide range of silhouettes and style lines (SEE CHEONGSAM; ROBE; SARONG; WRAPPER). Most gowns are one piece, but there are exceptions for style, fit, and versatility. The gown has a long, global history as gender-neutral apparel, but in seventeenth-century Europe the term was increasingly identified with women. Over the course of the eighteenth century, the term "dress" came into more common use, and since

the mid-twentieth century, "gown" generally refers to formal or bridal wear. Types of gowns are often described by time and purpose (evening gown, nightgown, wedding gown, sun or summer dress) or style reference (coatdress, shirtdress, minidress). Men throughout the world still wear one-piece, robe-like garments as regional dress; for ceremonial purposes; or to designate membership in the clergy, a governmental or judicial body, or academia.

Chemise A slim, columnar gown with a very high waistline and usually a low neck and short sleeves, worn during the late eighteenth and early nineteenth centuries in Europe and North America. Inspired by the ancient Greek CHITON, these gowns (also called Empire or Regency) were often made of a diaphanous fabric that required lining and allowed the skirt to flow naturally along the body.

Chiton Fashioned from a large rectangle of fabric draped around the body, or two rectangles seamed at the side, with either type pleated and fastened at the shoulders. Worn by women in ancient Greece, and often tied with a cord at the waist, it is called a peplos when it features an additional bodice that flows over the upper part of the gown, from the shoulders to a flared hem at the hips.

Cotehardie A medieval European gown with long, tight sleeves, cut of four shaped, vertical panels and fastened with laces to fit close to the body. The cotehardie was an elite garment, mostly for women, and made of luxury fabrics like velvet or silk.

Houppelande A voluminous late-medieval gown worn in Europe. Sewn of circular panels, it featured open, often ornate sleeves and was worn belted over a slimmer gown.

Kirtle A slim undergown worn by women in Europe from the tenth through the sixteenth centuries.

Mantua A loose gown with an overskirt, cut fuller in the back than in the front. Originally an informal gown for private wear, the mantua became fashionable as the sacque-back dress in the eighteenth century (SEE SACK). The term was also used generically to mean "gown," as in "mantua maker" for dressmaker.

Princess line A close-fitting, waistless silhouette composed of six fitted panels and fastened with buttons or a zipper. Conceived by designer Charles Frederick Worth in the 1860s to attract the patronage of Alexandra, Princess of Wales, it was revived repeatedly in the twentieth century, notably in the 1960s for both day and evening dresses.

Robe à l'anglaise An eighteenth-century European gown with a fitted bodice and full skirt, worn without panniers (SEE HOOP/PANNIER).

Robe à la française An eighteenth-century open-fronted European gown worn with a STOMACHER, a decorative petticoat (SEE UNDERGARMENTS/PETTICOAT), and panniers.

Sheath A columnar silhouette encasing the body from shoulders to hem, which may be fitted to the body's contours or skim them.

Tea gown An informal yet elegant gown, generally waistless, worn at home, in the afternoon, in private or with family and close friends. Popular in the later nineteenth and early twentieth centuries, the tea gown served as a comfortable ensemble (often worn with a loosened corset) to wear between day and evening events. More elaborate than a dressing gown, tea gowns often featured novelty style lines inspired by historic or imported garments, and unusual trims and fabrics.

James McNeill Whistler (American, 1834–1903), *Symphony in Flesh Color and Pink, Portrait of Mrs. Frances Leyland*, 1871–74. Oil on canvas, 195.9 × 102.2 cm (77⅛ × 40¼ in.). New York, Frick Collection, Henry Clay Frick, 1917.1.133

James McNeill Whistler designed the sitter's flowing gown as well as the drawing room decor in her Chelsea home. Worn to receive guests, tea gowns often harmonized with the color palette or historic period decor of a woman's parlor.

Gusset

A diamond-shaped or triangular piece of fabric inserted under the arm or in the crotch of a garment to add volume, to ease, or to reinforce the element. In chainmail suits, strips of flexible material at the joining of two sheets of mail were also called gussets (SEE ARMOR).

Guglielmo Giraldi (Italian, active 1445–89), *Saint Catherine of Bologna*, from the Gualenghi-d'Este Hours, ca. 1469. Tempera colors, gold paint, gold leaf, and ink, 10.8 × 7.9 cm (4¼ × 3⅛ in.). Los Angeles, J. Paul Getty Museum, 83.ML.109.185 v; Ms. Ludwig IX 13, fol. 185v

The simple, dun-colored habit of the Order of Saint Clare represents a cloistered life of penance and prayer following the teachings of Saint Francis of Assisi. Strict adherence to poverty vows led to members being known as "Poor Clares."

Habit

A manner of dress that identifies the wearer with a profession, an affiliation, a rank, or a type of service. In Europe in the Middle Ages, the term summarized an individual's garments without an association, but it subsequently acquired its more current specificity in reference to the restrictive dress codes for members of religious orders. In the seventeenth century, "habit" also designated a man's ensemble in which the elements—usually doublet (SEE JACKET/DOUBLET) and breeches, but also cloak and stockings—were the same color (SEE RIDING HABIT).

Hanbok

The collective term for traditional Korean dress. With origins dating as far back as the Three Kingdoms period (the first century BCE to the seventh century CE), *hanbok* consists of a *chogori* (long jacket) with a rectangular-cut sleeve worn over trousers or a wrapped, floor-length underskirt. The V-shaped neckline is edged with ribbon, and a detachable white collar is worn beneath. The *chogori*, which may be any length, is tied high on the chest. By the later nineteenth century, the term *hanbok* was used to distinguish Korean everyday dress from the Western equivalent. By the twentieth century, the traditional style was inscreasingly reserved for ceremonial and other formal occasions such as weddings and funerals.

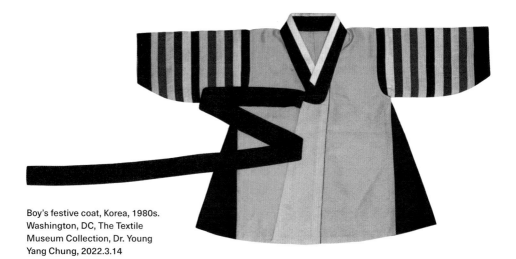

Boy's festive coat, Korea, 1980s. Washington, DC, The Textile Museum Collection, Dr. Young Yang Chung, 2022.3.14

In contemporary South Korea, October 21 is celebrated as Hanbok Day, a government initiative to promote the garment. These vibrant ensembles preserve traditional style lines while appealing to modern tastes.

Hanfu

Traditionally, a collective term for Han Chinese male dress, consisting of a loose, flowing robe with wide sleeves worn over trousers or an underskirt. The characteristic style line, in which the open-front robe is cross-closed and secured with a sash at the waist and worn over a shirt with a crossed (often detachable) collar, is generally traced to the Han dynasty (206 BCE–220 CE) but has ancient roots and endured long after Manchu rulers introduced their own style of dress and imposed restrictions on wearing *hanfu* in the seventeenth century (SEE CHANGSHAN).

Bonnet

Headwrap

Caul

Phrygian cap

Fez

Toque

Headwear (hat, headdress)

Any item of apparel that is worn on the head. Hats may provide warmth, protection, or decorative flair. They can also serve as symbols of affiliation, rank, piety, or individuality. Worn throughout history, hats have been associated with a strict decorum: when they are worn and when to remove them; particular circumstances and occasions; requirements as the finishing element of an ensemble. The global ubiquity of hats means that they have taken almost numberless variations. Types and styles have also been widely appropriated and modified across cultural, historical, and gender conventions (SEE HOOD; TURBAN; WIMPLE).

Beret A round hat, often of wool or felt, with a flattened silhouette that fits tightly around the crown of the head.

Bonnet Once a generic term, by the eighteenth century it referred to hats for women, children, and infants, especially ones that enclose the back and sides of the head and are tied with bands or ribbons.

Bowler Designed by London hatmakers Thomas and William Bowler in 1849, a stiffened felt hat with a low, rounded crown originally worn by estate groundsmen and gamekeepers as a practical alternative to the top hat. It was quickly adopted by middle-class and aspirational working-class men throughout the English-speaking world, notably in the US West. By the 1910s, it was conventional headwear for city office workers. Introduced in Bolivia by British rail workers in the 1920s, the bowler appealed to local Indigenous women and is now part of their traditional dress.

Cap Derived from the Roman *cappa* (hooded cloak), a simple, small hat that fits snugly around the crown of the head. Made of cotton, wool, felt, or leather, a cap often has a visor.

Caul A large mesh cap, sometimes made of metallic threads and embellished with beads and pearls, that encloses the hair. Worn by elite women in Europe, particularly from the sixteenth through the eighteenth centuries, cauls were often combined with other headwear; in the Middle Ages they were also called frets.

Cocked hat A stiffened, wide-brimmed, high-crowned men's hat worn from the seventeenth to the nineteenth century, particularly by members of European military. Often trimmed with a cockade, hence the name, the hat sits straight on the head with the brim turned back and fastened to the side of the hat's crown (upper section) with buttons or loops. The crescent-shaped bicorne has the front and back pressed together to create points on the sides. The triangular tricorne features three sides and three points.

Coif A small, white, close-fitting cap, often tied under the chin, generally worn under another hat for hygiene or protection from rough materials. It was worn by women and men (especially under helmets) in Europe throughout the Middle Ages, by infants and toddlers into the early twentieth century, and as part of a nun's habit in some orders.

Dorothy Wilding (British, 1893–1976) and Beatrice Johnson (British, 1906–2000), *Queen Elizabeth II*, 1952. Hand-colored bromide print, 31.6 × 24.8 cm (12½ × 9¾ in.). London, National Portrait Gallery, NPG x125105, given by the photographer's sister, Susan Morton, 1976

The diamond diadem created for King George IV's coronation in 1820 has since been worn by British queens and queen consorts. Flanking the front cross, diamond "floral" sprays in the shapes of roses, shamrocks, and thistles represent the national emblems of England, Northern Ireland, and Scotland.

Crown A circlet—often substantial, made of precious materials—that designates royal rank. The silhouette, material, and significance varies with cultures. It may also refer to a garland of foliage or flowers worn to honor accomplishment in athletics or battle, or for a ceremony such as coming of age or marriage.

Fez A felt hat—often red—with a truncated conical silhouette and topped with a silk tassel. Named for the city in Morocco while under Ottoman rule, the fez was regarded as the national headwear for Turkish men from the early nineteenth century until 1925, when it was banned by the founding president of the Republic of Turkey, Mustafa Kemal Atatürk, as part of his campaign for modernity and secularization.

Headwrap A length of cloth arranged around the head for protection, comfort, or decorative flair. Worn throughout time and across the globe, headwraps can conform to regional traditions, status, and marital circumstance. Wrapping techniques are often artful, with individual variations (SEE *KANGA*; TURBAN).

Helmet Protective headwear, particularly for combat, usually covering the whole head and neck and made of metal, leather, or any other material that resists penetration. Battle helmets may be decorated to proclaim identity or affiliation, or with a fierce aspect so as to unnerve an adversary.

Hennin A tall, stiffened and shaped hat, with many variations, worn by elite women in Europe during the Middle Ages. Popular silhouettes included a flat-topped toque (SEE HEADWEAR/TOQUE), very tall, pointed steeples, and butterfly and horn shapes. Most were elaborately decorated with lavish materials, metallic embroidery, and precious stones, and finished with a veil of diaphanous fabric or lace.

Coëtivy Master (Henri de Vulcop) (French, active 1450–85), *Philosophy Presenting the Seven Liberal Arts to Boethius*, ca. 1460–70. Tempera colors, gold leaf, and gold paint, 6 × 17 cm (2⅜ × 6¹¹⁄₁₆ in.). Los Angeles, J. Paul Getty Museum, 91.MS.11.2v

The women's attributes here represent the liberal arts, but their hennins, ranging from the elaborate butterfly on the left to the conical, veil-draped steeples in the center and on the right, display cutting-edge fashions.

Kufi A round, brimless, close-fitting toque worn by men in North African and South Asian countries as a mark of status and religious affiliation (SEE HEADWEAR/TOQUE).

Phrygian cap A soft hat with a conical crown finished with a bent point. It can be traced to ancient Mediterranean and Mesopotamian cultures, and gave form to the *pileus*, the cap worn by emancipated slaves in ancient Rome. Worn for agricultural work throughout Europe in subsequent centuries, it was adopted in a specific red wool version as a symbol of support for the French Revolution (1789–99) and retained that association through the nineteenth century.

Skullcap A small, GORED cap that sits on the crown of the head and is often worn as a symbol of religious affiliation (for instance the Jewish yarmulke), age, or status.

Sombrero A wide-brimmed hat with a tall, tapered crown, worn by men in Mexico and other Central American countries. The name derives from the Spanish word *sombra*, or shadow, referring to the wide brim, and the shape reflects that of the hats worn by horsemen of the Iberian peninsula. The sombrero was adapted by North American cowboys into the so-called ten-gallon hat.

Top hat With a high, cylindrical silhouette, a flat top, and a modest brim, the top hat came into fashion for men in Europe in the late eighteenth century. Made of brushed silk, beaver fur, or felted rabbit fur, these hats were worn for riding and day wear through the nineteenth century; they survived through the twentieth as an elegant formal accessory. Women may wear them for riding or as a fashionable novelty.

Toque A high-crowned, brimless silhouette with many variants across eras and cultures. Toques have provided a basic form for crowns, helmets, and, most recently, fashion.

Hem

A finishing technique that hides and stabilizes the raw fabric edge of a garment. Hems are also used to shorten the length of sleeves, shirts, trousers, skirts, coats, and dresses. In a simple hem, to prevent raveling, fabric is doubled back under the garment. The raw edge may be trimmed with pinking shears, folded in again, covered with binding, or enclosed with a facing or piping. The hem is then stitched in place, usually with an overcast stitch (SEE STITCH/OVERCAST STITCH).

Banded hem The edge of a garment that is completely enclosed in a band of the same or contrasting fabric.

Blind hem Stitches hidden beneath the finished edge for a clean line.

Circular hem Excess fabric evenly eased at the raw edge before stitching so as to accommodate the extra width at the circumference of a circle form, typically a skirt.

Frayed edge Leaving the edge of the fabric raw to unravel as a decorative effect. It may be secured with stitching or a binding just above the unraveled threads.

Lettuce hem The edge of a garment encased in tight zigzag or overcast stitching to create a crisp, curling contour resembling that of a lettuce leaf. It gives movement to the hem and works best on fine knits and other light fabrics with stretch.

Lingerie hem A rolled, overcast hem, with tiny puffs in the intervals between stitches. It is traditionally a hand finish for fine undergarments and requires very delicate fabrics.

Rolled hem Used with delicate or sheer fabrics, where the the raw edge is smoothly rolled in and secured with small, blind stitches.

Scalloped hem A contour of repeated half-rounds at the edge of a garment created with facings.

Weighted hem A light chain or tiny weights enclosed within the hem to enhance the hang and prevent the lower edge of a skirt from rising during movement or being lifted by the wind.

Hemline

The lower edge of a skirt, distinctive for its length or contour. The name may refer to a specific point on the leg (ankle, calf, knee, above-knee); the length (midi, mini); or the shape, influence, or purpose for which the garment was designed. Hemlines may also be embellished with ruffles and flounces, bands of fabric, embroidery, pleats, or tucks.

4918

Mary Quant (British, b. 1934), *Fireworks*,
1966–70 (designed), drawn by Janie Ranger
for the exhibition *Mary Quant's London*,
London Museum, Kensington Palace,
1970(?)–74. 35.3 × 24.9 cm (13⅞ × 9¹³⁄₁₆ in.).
London, Victoria & Albert Museum,
E.520-1975, given by Mary Quant

In the 1960s, miniskirts rose to unprecedented
heights. To offer full coverage beneath the thigh-
high hemlines, designer Mary Quant developed
a line of colorful tights.

Asymmetric hem (diagonal hem)
A slanted hem, angling from side to
side or back to front.

Ballerina A skirt length hitting
midway between knee and ankle.
If the skirt is made of layered tulle or
a similar fabric, the edges are cleanly
cut to the same length.

Bubble A wide lower edge gathered
in to give a rounded form to the
whole skirt.

Fishtail Flared at the back to simulate
a fish's tail, often in the form of a train.
A more extreme line than asymmetric
or high-low, it is also called mermaid
(SEE HEMLINE/ASYMMETRIC; HEMLINE/
HIGH-LOW).

Fluted hem The hem of a skirt that is
fitted over the hips but widens to create
a flared effect at the lower edge.

Handkerchief hem When the edge of
the skirt falls in a series of points that
evoke the natural drape of a handker-
chief held in the center.

High-low hem Longer in the back
than the front, with a gradual rise
at the sides.

Shirttail hem Elongated and rounded
at the front and the back, resembling
the tails of a contemporary man's
dress shirt.

Tea-length hem A hemline falling
two to four inches above the ankle. The
name derives from the 1920s as the
appropriate length to wear for a formal
afternoon tea.

Ballerina hem

Fluted hem

Handkerchief hem

Himation

An ancient Greek garment formed from a wrapped rectangle of cloth roughly three to four yards long and one to two yards wide, made of a length of light wool or linen. One end is draped over the left shoulder, and the rest is drawn under the right arm and WRAPPED around the body. It may be worn over a TUNIC or on its own, and although the wrap resembles that of a toga, a himation is less voluminous. And unlike a chlamys, it is not pinned (SEE CLOAK/CHLAMYS). The Romans adopted it, calling it a pallium. A Roman women's version was called a palla, which was the characteristic garment of respectable matrons.

Hood

A covering for the head and neck, which may extend from another garment such as a jacket or coat, or may be separate headwear that ends at the base of the neck or extends, cape-like, over the shoulders. With practical origins, hoods appear on all types of garments to add warmth, protection against the elements, or embellishment. The head opening can be hemmed, trimmed (notably with fur), or adjusted with a drawstring. The form may be soft, to follow the shape of the head or to drape down the back of the garment, or it may be shaped for decorative effect or padded for warmth. Hoods—separate or attached to robes—designate clerical and academic distinction. They also may have a sinister aspect, as when covering the full head to block vision, or as a disguise, such as an executioner's hood or part of Ku Klux Klan regalia. Hoods are also designed for specific protections, as in firefighting, chemical cleanup, or diving.

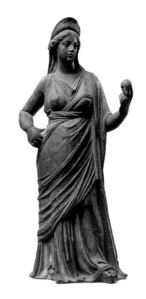

Statuette of Aphrodite, Eastern Mediterranean or Greek, ca. 200–150 BCE. Bronze, 38 × 18.5 × 13.7 cm (14¹⁵⁄₁₆ × 7⁵⁄₁₆ × 5³⁄₈ in.). Pacific Palisades, California, Getty Villa, 96.AB.149, gift of Barbara and Lawrence Fleischman

Dressed as an affluent matron, the goddess wears a himation over her chiton (draped gown). The draped length of fabric sweeps asymmetrically across her lower body, with the loose end falling free over the shoulder.

Amuati The large hood of a parka or anorak worn by Inuit women that can warm and shelter an infant (SEE COAT/PARKA; JACKET/ANORAK).

Balaclava A knitted, pullover hood covering the head and shoulders with a front opening that can expose as little as the eyes or as much as the front of the face, named for the 1854 Battle of Balaclava in the Crimean War.

Chaperon A soft hood, draping over the shoulders, with a tail (liripipe) extended from the crown. Worn throughout medieval Europe by men of all ranks, by the late fourteenth to the mid-fifteenth century the *chaperon* became a sign of mercantile wealth, made of expensive textiles and with a very long liripipe that was wrapped around a ring-shaped base (bourrelet) to create a turban-like form.

Cowl A loose, tubular hood that encircles the neck or is pulled up on the head, derived from a monk's habit (SEE COLLAR/COWL).

Hoodie A sweatshirt with a soft, head-contoured hood whose opening adjusts with a drawstring.

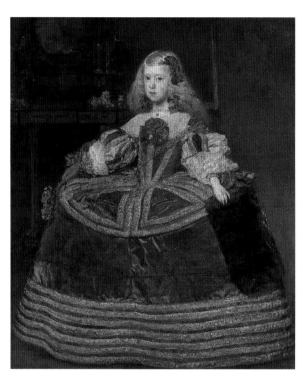

Diego Rodríguez de Silva y Velázquez (Spanish, 1599–1660), *Infanta Margarita in a Blue Dress*, 1659. Oil on canvas, 127 × 107 cm (50 × 42 in.). Kunsthistorisches Museum Vienna, Gemälde-galerie, GG_2130

The heavy skirts of the princess's gown are supported by a wheel farthingale, named for the cartwheel-like frame tied to the waist under the skirts. The hoop dips lower in the front, pushed down by the point of the stomacher.

Hoop

A rounded, circular, or oval support worn under a garment—typically a skirt—to shape the silhouette. Hoops were used in Europe and Western-influenced regions when skirts were voluminous, particularly from the seventeenth century to the second half of the nineteenth, but smaller hoops and padded rolls were also used to give form to slimmer styles (the shape and size of the hoop depended upon the desired silhouette). Made as either a single form or a framework, hoops were typically made of cane, whalebone (baleen), or, after the mid-nineteenth century, steel (SEE CAGE CRINOLINE; SUPPORT).

Drum A single, plate-like form made of whalebone, jutting out at the waist. The skirt fabric covers the plate and then drops down over the edge, with the lower portion of the skirt supported with multiple underskirts. Also called a wheel hoop.

Farthingale Hoops of wood, wire, or whalebone sewn at intervals into an underskirt of heavy linen, worn in the sixteen and seventeenth centuries.

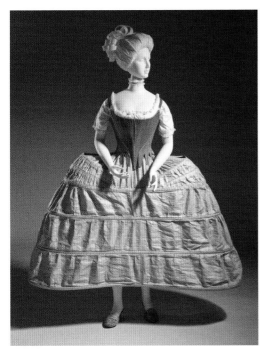

Women's hoop petticoat (pannier), English, 1750–80. Linen plain weave and cane. Los Angeles County Museum of Art, M.2007.211.981, purchased with funds provided by Suzanne A. Saperstein and Michael and Ellen Michelson, with additional funding from the Costume Council, the Edgerton Foundation, Gail and Gerald Oppenheimer, Maureen H. Shapiro, Grace Tsao, and Lenore and Richard Wayne

Wide hoops, worn under skirts, created the distinctive flat shape favored in eighteenth-century European court circles. The name "pannier" derives from the pair of baskets that fastens across the back of a pack animal.

Pannier A frame of cane or whalebone extending the sides of a skirt, leaving the front and back flat, generally made in two parts and tied on to the stays (SEE CORSET/STAYS). It was in use in the mid- to late eighteenth century.

Jacket

A garment with sleeves for the upper body—all ages, all genders—usually worn over other clothing. Jackets may or may not close in the front, and collars, fit, sleeve length, and other style lines vary. Names reflect weight (summer, winter), fabric (leather, buckskin), or perhaps a prominent individual associated with the style (Mao, Nehru). Jackets may also signify an affiliation (club jackets) or be part of a matching ensemble (SEE SUIT).

Anorak A hip-length pullover with a hood, inspired by the sealskin garments worn by Indigenous peoples of the Arctic region. It is generally water repellent and can be lined for warmth.

Battle jacket Waist length, made of a sturdy cotton or wool, and deriving from the US Army jacket worn by General Dwight D. Eisenhower in World War II. It has bands at the waist and cuffs, a convertible collar (SEE COLLAR/CONVERTIBLE COLLAR), and patch breast pockets.

Bolero An unfastened brief jacket with rounded front and hem. It is based on the Spanish bullfighter's *traje de luces* (suit of lights, so-called for the metallic stitching), named after a musical form, and more commonly worn by women than by men.

Daniel Maclise (Irish, 1806–1870), *Portrait of Edward Bulwer Lytton*, in *Frasier's Magazine*, 1832. Lithograph, 19.4 x 12.7 cm (7⅝ × 5 in.). London, British Museum, 1926,0331.770

This well-fitted frock coat has high armscyes and a four-panel upper back that tapers to the waist. The back skirts are fuller than the front, with a central pleat accented with decorative buttons.

Cutaway A man's skirted jacket adapted from equestrian wear, with a wide-open slanted front and vented back.

Dinner jacket Created as an informal entertaining style for Edward, Prince of Wales, in 1865. Although more conservative in color and fabric, it resembles a smoking jacket (SEE JACKET/SMOKING JACKET; SUIT/TUXEDO).

Doublet A close-fitting sleeved garment worn by men in Europe between the fifteenth and seventeenth centuries. The name derives from the doubling of the fabric on the torso for shape and stability. It is often worn under a jerkin, cloak, or coat.

Frock coat A long (often knee-length) jacket with a waist seam and a skirt designed for country leisure activities in the later eighteenth century. By the mid-nineteenth century it was worn in a slim silhouette as formal daywear, often with contrasting trousers.

Garibaldi A woman's blouse or jacket, popular in the 1860s, made of red wool and trimmed in black braid. It was named for the Italian patriot Giuseppe Garibaldi (1807–1882).

Mao jacket A Chinese TUNIC with four pockets and a small turned collar, worn from circa 1912 through the end of the twentieth century. It was named for leader Mao Zedong (1893–1976) and seen as a symbol of the proletariat (SEE SUIT/ ZHONGSHAN SUIT).

Spencer jacket, France, ca. 1815. Cotton plain weave. Los Angeles County Museum of Art, M.2007.211.15 a,b, purchased with funds provided by Suzanne A. Saperstein and Michael and Ellen Michelson, with additional funding from the Costume Council, the Edgerton Foundation, Gail and Gerald Oppenheimer, Maureen H. Shapiro, Grace Tsao, and Lenore and Richard Wayne

According to legend, when the tails of the Earl of Spencer's tailcoat caught fire, he had it re-tailored into an abbreviated jacket. Whatever the origin, the Spencer jacket was brief, snug, and decorative, well suited for women to wear over high-waisted gowns.

Nehru jacket Based on a traditional Indian garment, a slim, long, single-breasted jacket with a standing collar, popularized by India's first prime minister, Jawaharlal Nehru (1889–1964), as an alternative to the Western business suit.

Norfolk jacket A British woolen hip-length jacket with front pleats, two bellows pockets (SEE POCKET/BELLOWS POCKET), and a belt slotted under the pleats, worn by men for country sports and leisure.

Smoking jacket From the eighteenth century forward, designed for men for informal entertaining. Essentially it is a short dressing gown (SEE ROBE/DRESSING GOWN) made of a luxurious fabric and featuring a shawl collar (SEE COLLAR/SHAWL COLLAR), buttoned or tied, worn over a formal shirt.

Spencer jacket A very short fitted jacket with long sleeves, worn by men and women in the later eighteenth century and then popular for women as a topper over lightweight chemise dresses (SEE GOWN/CHEMISE).

Swallowtail An element of men's formal wear, an open jacket with peaked lapels featuring a waist-length front and two taillike extensions from the back waist seam.

Zouave jacket A woman's jacket, popular in the mid-nineteenth century, resembling a voluminous bolero with three-quarter-length sleeves. It was adapted from the traditional uniform of Algerian soldiers, who retained the style when serving as a light infantry corps in the French Army between 1830 and 1962.

Guide

Kehinde Wiley (American, b. 1977), *Officer of the Hussars*, 2007. Oil on canvas, 274.8 × 267.8 cm (108³⁄₁₆ × 105⁷⁄₁₆ in.). Detroit Institute of Art, 2008.3, museum purchase, Friends of African and African American Art

Kehinde Wiley employs clothes to reenvision Théodore Géricault's 1812 portrait of a Napoleonic-era cavalry officer. The young man's contemporary "uniform" consists of an athletic shirt, Timberland boots, and well-worn, low-riding jeans.

Jeans (blue jeans)

Durable, ankle-length, fly-front trousers, usually made of blue denim, originally designed as work wear for men. The word derives from the French *Gênes*, referring to Genoa, where sailors favored sturdy pants made of heavy cotton or wool twill (fustian), often dyed with indigo. Jeans acquired a US identity in 1873 when Nevada tailor Jacob Davis and San Francisco merchant Levi Strauss filed a patent for a design featuring distinctive copper rivets at the pockets. By the mid-twentieth century, blue jeans were a symbol of youth and rebellion, and within a decade they had gained global status as an iconic, gender-neutral garment for all ages.

Kassamali Gulamhussein (designer), *Kanga*, made in Tanzania, 1950–59. Machine printed cotton, 108.6 × 153.7 cm (42¾ × 60½ in.), Chicago, Art Institute of Chicago, Vedder and Price Fund, 2022.1490

A *kanga* is purchased as a connected pair of panels that are separated before wearing. The Kiswahili inscription offers gratitude for domestic comforts: "Thank you for the sofa for our honorable ones."

Kanga

A flat length of cloth that can be worn as a wrapped skirt or dress, as a cape or apron, or as headwear (SEE HEADWEAR/HEADWRAP; WRAPPER). *Kangas* were first created in Kenya and Tanzania in the 1850s out of uncut lengths of cotton manufactured by the Portuguese to be made into handkerchiefs. These were sewn together to make a large square and often finished with a decorative border in a contrasting pattern. In traditions associated with coastal East Africa and Madagascar, *kangas* feature inscribed messages that range from proverbs and warnings to slogans and pop-culture references. As well as versatile garments worn mostly by women, *kangas* are used to carry babies or wrap packages, and

may be twisted into a ring to make a head cushion (for comfort when carrying bundles). Along with cotton, contemporary *kangas* are made of silk and a range of synthetics.

Keffiyeh (kaffiyeh)

A man's headdress made of a large square of cotton draped over the crown of the head and secured with an encircling twisted cord or cloth (*agal*). It may have a tasseled edge trim, and has a distinctive checked pattern in red or black, although it also can be plain black or white. The term references the Iraqi city of Kufa on the Euphrates River, but the exact origins of the headdress are unknown. Keffiyehs have long been part of traditional men's dress throughout the Arab world, and since the 1970s, in association with the Palestinian quest for a nation-state, they have signified Arab identity and resistance. Keffiyehs are also sometimes used as neckwear.

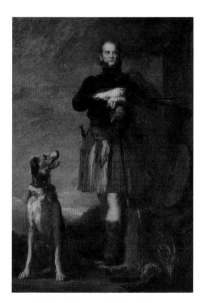

David Wilkie (Scottish, 1785–1841), *Augustus, Duke of Sussex*, 1833. Oil on canvas, 252.7 × 162.6 cm (99 ½ × 64 in.). London, Royal Collection, RCIN 405420

King George III bestowed the title Earl of Inverness on his sixth son. He appears here in that identity, wearing a kilt and a sporran (fur pouch) as well as the regalia of the Order of the Garter: a blue-trimmed sash and, topping his left stocking, a garter inscribed *Honi soit qui mal y pense* (Shame on who thinks evil of it).

Kilt

The traditional lower-body garment worn by men in the Scottish Highlands. Created out of a length of sturdy wool, sections of the kilt—generally the back and sides—are folded into pleats and secured so that the garment wraps around the wearer's body with a generous overlap in front, which is fastened with a decorative pin. Prior to the early eighteenth century, the belted plaid functioned as both the upper outer garment and the lower garment; the kilt evolved out of the lower half, covering the body from waist to knees (SEE SHAWL/PLAID). At that time kilts were associated with the quest to reinstate the Stuart Dynasty in Britain known as the Jacobite Uprising. The Dress Act of 1746 banned "Highland dress" as a means to weaken the spirit of the clans. The uprising was crushed at the Battle of Culloden that same year, but the ordinance was not repealed until 1782, with the exception of elite military units such as the Black Watch regiment. Ironically, the British monarchy embraced Highland traditions in the nineteenth century, with male members of the royal family wearing kilts when in Scotland, a tradition that continues today. Kilts are currently worn for Highland sports and festivals, and as a statement of heritage. Several contemporary designers have interpreted the kilt as an alternative skirt style for men. A woman's skirt that is pleated and features an overlap is also called a kilt.

83

Guide

Young woman's samurai-class outer kimono, Japan, late Edo period, early nineteenth century. Silk-figured satin with stenciled imitation tie-dye and silk- and gilt-paper-wrapped silk thread embroidery. Los Angeles County Museum of Art, Costume Council Fund, AC1999.177.2

Made for a privileged young woman, this *uchikake* (outer kimono) features swinging sleeves (*furisode*) and an embroidered pattern of flowers and clouds. The artful arrangement of the garment on the wearer's body indicates her good taste and respectability.

Kimono

The traditional garment for men and women in Japan. Customarily made from a single bolt of fabric (silk or cotton), it is constructed with straight seams at right angles, such that the T-shaped piece creates a column-like silhouette when worn on the body and falls to the ankles. The term, a conjunction of *ki* (to wear) and *mono* (thing), originated in the Meiji era (1868–1912) to differentiate Japanese dress from the rising influence of Western styles. The prototype traces to the Heian period (794–1185), when the samurai class, followed by the aristocracy, adopted the simple outer coat of the working classes. Over the centuries the kimono became increasingly elaborate as a display of wealth, featuring splendidly printed and embroidered silks, contrasting linings, and layers, and wide, folded sashes around the waist (SEE OBI). During the Edo period (1603–1867), to counter this excess, the ruling Tokugawa shogunate imposed a series of sumptuary laws. No matter the display, the essential kimono silhouette endured with sleeve variations. In terms of style lines, it may or may not have lapels, may be worn open or overlapped left over right, may have lapels or a collar, and may be padded for warmth or shape.

Furisode With elongated or swinging sleeves, worn by young, single women.

Koshimaki An outer robe secured with an OBI and artfully draped at the hips. This is a display garment, often richly embroidered.

Kosode Meaning "small sleeve," in reference to the small opening for the hand rather than the size of the sleeve.

Ōsode A kimono with the sleeve seam left open.

Uchikake A kimono worn as an outer garment draped over the shoulders, with a padded hem to stabilize the drape.

Yukata A short, unlined, informal kimono made of cotton, often indigo dyed to evoke water or cool air, worn in the summer or at bathhouses.

Jean Fouquet (Flemish, ca. 1420–1481), *Virgin and Child Surrounded by Angels*, right panel of the *Melun Diptych*, ca. 1453–55. Oil on panel, 94.5 × 85.5 cm (37⅛ × 33⅜ in.). Antwerp, Belgium, Royal Museum of Fine Arts, 132

The iconography of the Virgo Lactans (Nursing Virgin) exemplifies the humanity of the Holy Mother and Child. While the front lacing facilitates nursing, it also shapes the sinuous silhouette of this courtly Virgin's kirtle (gown).

Lacing

A means of fastening a garment by passing a cord, string, or ribbon (a lace) through a row of eyelets on either side of an opening. It may also be a mechanism used to adjust the fit of a garment, especially in a bodice, corset, or stays (SEE CORSET/STAYS). The most common pattern is a series of crosses, passing either over or under the garment, beginning with the laces pulled even through a horizontal pass and ending with them tied securely together (SEE FASTENINGS AND CLOSURES/EYELET).

Aglet A small metal or plastic tube covering either end of the lace to facilitate passing it through the eyelets.

Ladder A straight, horizontal pattern of lacing created by passing only the right lace through all the eyelets. The left lace is passed through the bottom eyelet to the inside, where it is drawn up, pulled out the top eyelet, and tied to the right lace.

Spiral lacing When one side has an extra eyelet, and the eyelets are staggered, so as to create a zigzag pattern of crossed laces.

Straight lace When the sides of the opening are placed together so the eyelets are one on top of the other and the lacing casts over the edge, resembling a whip stitch (SEE STITCH/WHIP STITCH).

Tight lacing Crossed laces closing a bodice or corset that are pulled very tight at each pass to reduce the size of the waist. Popular during the nineteenth century, many tight-lace corsets had hooks in the front to allow some temporary comfort without undoing the laces.

Lapel

The folded-back element on either side of the top front opening of a blouse, coat, jacket, or waistcoat. The term derives from the French *lappet*, or small flap. In the eighteenth century, the lapel appeared as a feature of jackets—generally military uniforms or riding habits—that buttoned to the neck. Facings and additional button-holes allowed the wearer to open and turn back the top of the jacket, creating lapels. A buttonhole in the left lapel accommodates a small flower (boutonniere) or a lapel pin; double-breasted garments have a buttonhole on each side. Lapels are typically joined to the collar by a seam and vary in silhouette. The exposed facings are some-times called revers (SEE COLLAR/REVERE COLLAR; REVERS).

Cloverleaf lapel Lapel with a rounded outer profile both above and below the joining seam.

L-shaped lapel Both lapel and collar having an angled outer profile, creating a notch at the joining seam; also called step, a style line of business garment and sport coat.

Peaked lapel Having a V profile where the lapel and collar join, with the slant of the lapel extending beyond that of the collar; also called "pointed," a style line of double-breasted garments and modern formal wear.

Shawl lapel Having a profile that forms a continuous curve with the collar, used on dressing gowns, smoking jackets, and tuxedo or dinner jackets.

James McNeill Whistler (Ameri-can, 1834–1903), *Arrangement in Gray and Black*, The Artist's Mother, 1871. Oil on canvas, 144.3 × 163 cm (56¾ × 64⅛ in.). Paris, Musée d'Orsay, RF 699

Widowed in 1849, Anna McNeill Whistler dressed in mourning for the rest of her life. Her frilled collar and cuffs, and the trailing lace lappets of her widow's bonnet, are the only ornaments on her severe black attire.

87

Lappet

A band of embellished fabric or lace attached to a headdress—particularly a woman's bonnet—for decorative or symbolic effect. Named for the flap-like wattles of some birds, lappets may be tied, but typically hang pendant from the crown or the edge of a hat (SEE HEADWEAR).

Leggings (hose, stockings)

Garments made to cover the legs and sometimes the feet, also called hose or stockings when covering the feet. Ancient leggings were made of wrapped strips of fabric. Fitted stockings, cut or knit to conform to the leg, emerged in Western nations by the thirteenth century. Over the next two centuries, European men's garments became shorter, until the mid-fifteenth century, when the whole length of the leg, encased in decorative leggings, was exposed. Elsewhere in the world, leggings remained hidden beneath other garments. Until the twentieth century, most leggings were designed in two pieces, with full-length leggings joined by ties at the waist (SEE CODPIECE). The term "stockings" refers to any length from thigh to ankle, with longer lengths secured by GARTERS. By the nineteenth century, the terms "hose" and "hosiery," once used for light leggings, became associated with women's wear as both a functional and a decorative garment. In the twentieth century, sleek, transparent weaves—silks and synthetics—became the standard for women's leg wear. Today, "leggings" refers to a footless, stretch-knit garment worn as athletic or casual attire; tights or pantyhose are coverings for the legs *and* the feet.

Paul Mercuri (Italian, 1804–1884), after Vittore Carpaccio (Italian, ca. 1460–1525), "Young Venetian Man," from Camille Bonnard's *Costumes Historique*, 1860. Hand-colored lithograph

Bicolored leggings, in this case one striped and one scarlet, proclaim affiliation with the Compagnie della Calza (Company of Leggings), a fraternity of young, affluent men dedicated to organizing civic entertainments in fifteenth-century Venice.

Lehenga

A collective term for an ankle-length skirt paired with a choli (SEE BLOUSE/CHOLI) and a *dupatta* (SEE SCARF). Worn throughout India, the skirt may be flared, full, or narrow, and sits below the waistline. The choli may have short or long sleeves, a high or low neckline, and an exposed back, and is tight fitting and brief, ending anywhere from below the bustline to just above the waist. As a festival garment—notably worn by brides—*lehengas* are made of eye-catching fabrics and embellished with sequins, metallic threads, and traditional embroidery patterns.

Rajasthan School, *Woman on a Swing*, in the style of Manohar of Mewar, ca. 1680–1700. Paint on paper. London, British Museum, 1999,1202,0.1.1

The slender skirt and tight, high-cut *choli* (blouse) display the supple figure of the woman on the swing, prompting her companions, according to the inscription, to wonder if her waist will snap.

Photograph of Jules Léotard, negative before 1870; print ca. 2000. Sepia photograph on paper, 9.4 × 5.7 cm (3¹¹⁄₁₆ × 2¼ in.). London, Victoria & Albert Museum, Guy Little Collection, GLCXIV.xi.5.1

Designed for ease of movement and physical display, Jules Léotard's maillot daringly exposes his body. The tight belt not only accented his narrow waist; it held the knitted garments in place as he performed acrobatics on the flying trapeze.

Leotard

An unlined, tight-fitting garment worn for dance or gymnastics. The earliest design, essentially knitted shorts and a tank top that allowed ease of movement while displaying the body, appeared in the later 1850s and is credited to aerialist Jules Léotard (1838–1870). Léotard called it a "maillot" (SEE SWIMWEAR/MAILLOT), but by the mid-1880s his name was linked to the garment. One-piece leotards, with variations on sleeve length, leg length, and neckline, became common, particularly for ballet practice, in the twentieth century as improved knitting technology added strength and stretch to the fabric. A leotard may also be worn as a layer (SEE SINGLET).

Body stocking (bodysuit) A one-piece, skin-tight, knit garment. It can have straps, sleeves, or a collar, and it may have legs and feet or end at the crotch. It was popular in the 1960s, worn as a fashionable top or as a layer.

Catsuit A full-body one-piece worn for athletic activities and fashion, with feet or straps under the arch of the foot to keep the legs smooth and tight. It can have a zipper.

Unitard A one-piece, step-in bodysuit worn for athletic activities. It may have sleeves, straps, or be sleeveless, but it always has legs.

89

Guide

Guide

Jean-Étienne Liotard (Swiss, 1702–1789), *Maria Frederike van Reede-Althone at Seven Years of Age*, 1755–58. Pastel on vellum, 54.9 × 44.8 cm (21 ⅝ × 17 ⅝ in.). Los Angeles, J. Paul Getty Museum, 83.PC.273

A fur lining adds warmth as well as luxury to an outer garment. This type of cape might feature a finer fur at the edges—the black spots suggest ermine—with something less valuable under the velvet.

Lining

An underlayer of fabric that provides warmth, stability, ease of fit, or modesty to a garment. Linings are typically constructed as identical to the garment, but separate, and eliminating elements such as collars, facings, waistbands, and cuffs. Fabrics are chosen for purpose, for instance fur or fleece for warmth; thin, tightly woven, and smooth-finished for fit and ease of wearing; or opaque under sheer. Linings can reinforce parts of garments under strain, particularly in the back. They can also provide a decorative contrast when a garment is opened, or make the garment reversible. Some warm linings feature buttons or zippers to make them removable.

Interlining A fabric layer between the lining and the outer garment that adds stability, particularly to coat and jacket fronts, collars, and cuffs. Stiffness may range from sturdy tailor's canvas and linen canvas to lighter crinoline and softer domette as well as nonwoven fabrics. It can also designate a warm layer in a coat or jacket that is not removable.

Partial lining A layer that reinforces only part of the garment.

Underlining Cut pieces of lining joined to the garment prior to construction; the doubled pieces are sewn as a single piece. Underlining is often used to stabilize a loosely woven fabric.

Loincloth (breechcloth)
A simple covering for the lower torso and tops of the legs. It may be wrapped around the body, wrapped and drawn between the legs, or created of two panels covering the back and front and secured at the waist.

Tomb of Nebamun, Egypt, Eighteenth dynasty, ca. 1350 BCE. Plaster, 98 × 98 cm (38⁹⁄₁₆ × 38⁹⁄₁₆ in.). London, British Museum, EA37977, purchased from Henry Salt

Schenti, or knee-length loincloths, were worn by people of all stations in ancient Egypt. As a mid-ranking official, Nebamun likely wore one of fine cotton secured with a linen belt.

Mask

A face covering, whole or partial, worn in most cultures for performance, ceremonies, disguise, protection, or, on occasion, fashion. It may attach with straps or ties, or be held by hand. Among the types that became fashionable, notably in eighteenth-century European elite society, was the domino, a half mask worn for balls and masquerades. Purpose-designed masks offer protection in such sports as baseball (catcher's mask), diving, and fencing. Masks have long been used by health-care providers; during the European Middle Ages, physicians treating the bubonic plague wore a well-secured, distinctive mask that covered the mouth and had a birdlike beak with very small breathing holes. In the belief that contagion spread in foul air, the beak held aromatic herbs or a vinegar sponge.

Paulus Fürst (German, 1608–1666), *Doctor Schnabel von Rom, Plague Doctor*, ca. 1656. Engraving, 30.1 × 21.6 cm (11⅞ × 8½ in.). London, British Museum, 1876,0510.512

To treat bubonic plague sufferers, physicians donned gloves and a hooded robe as well as a full-face mask with eyeholes and a beak. Rather than a grotesque affectation, the beak held medicinal substances that were believed to protect against contagion.

Neckline

The style line that defines the top edge of an upper-body garment. It may be plain or embellished, with a collared or collarless opening for the head. Necklines may rise up the base of the neck, plunge to the sternum or the waist, and/or expose parts of the upper body, including the back and shoulders. Basic necklines are often described by their shape, as in round neck, square neck, scoop neck, V neck, or U neck (SEE BLOUSE; COLLAR; GOWN; SHIRT).

Bateau (boatneck)　　　　　Drawstring　　　　　Surplice

Bateau (boatneck) A straight neckline along the collarbone, derived from the *marinière* or striped Breton sailor's jersey.

Camisole A low, straight cut across the front and back with supporting straps.

Crew neck A plain, rounded line that sits at the base of the neck.

Décolleté A low neckline on a woman's gown, generally a feature of formal evening dress and sometimes filled in with sheer, contrasting neckwear (SEE NECKWEAR/TUCKER; SCARF/FICHU).

Drawstring neckline (shirred neckline) A wide-cut neckline that is gathered into the body with a drawstring, common in traditional women's agricultural garments.

Halter The neckline of a sleeveless garment that fastens around the neck with a band or a tie, exposing the shoulders; it may also expose the back.

Off the shoulder A wide cut that bares the front of the chest and shoulders, with a line that sits high on the upper arm, structured with boning or elastic to prevent slippage.

John Singer Sargent (American, 1856–1925), *Portrait of Madame X (Madame Pierre Gautreau)*, 1883–84. Oil on canvas, 208.6 × 109.9 cm (82⅛ × 43¼ in.). New York, Metropolitan Museum of Art, 16.53, Arthur Hoppock Hearn Fund

A sweetheart neckline tops the self-supporting, heavily boned bodice of this daring gown. John Singer Sargent initially painted the right diamond strap as slipping off the sitter's shoulder, causing a scandal when the portrait debuted.

Portrait neckline A décolleté cut that sits on the outer contour of the shoulders, often reinforced to prevent slipping.

Strapless A garment without sleeves or straps that is supported with a stiff lining, boning, elastic, or SHIRRING.

Surplice An asymmetrical V shape created by overlapping the sides of the bodice; a wrapped style.

Sweetheart neckline A décolleté that is rounded over the breasts and may or may not have straps or other supporting structure (SEE NECKLINE/DÉCOLLETÉ).

Neckwear

An additional element, usually decorative, added at the neckline or used to finish the collar treatment. As varied in form as it is universal, neckwear may also symbolize an affiliation, gender, or rank in an organization (SEE BANDANNA; COLLAR; RUFF; SCARF).

Ascot An oblong strip crossed over in front and either looped over or secured with a pin. It may be tucked into the shirt neckline.

Bow tie A strip of fabric with square or shaped ends that is fitted under the collar and tied in a bow. Introduced as an informal tie in the late nineteenth century, it is now worn with a tuxedo. A pre-tied version is called a band bow.

Cravat A general term that encompasses a wide, often loose tie, which by the late nineteenth century was generally colorful and tied in a soft bow.

Dickie A man's detachable, bib-shaped shirtfront, attached to the collar and tucked into the waistcoat, sometimes fastened to the trousers with a buttoned tab. It was known as a detachable bosom in the later nineteenth century, when it was occasionally made of celluloid (first introduced at the 1862 London International Exhibition as a fabric alternative).

Jabot A cascade of ruffles down a shirt front, which may be fixed to a stock and tied on (SEE NECKWEAR/STOCK).

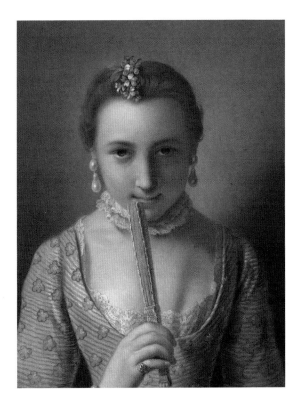

Pietro Antonio Rotari (Italian, 1707–1762), *Young Woman with a Fan*, early 1750s. Pastel on paper, mounted on canvas, 46 × 37 cm (18⅛ × 14⁹⁄₁₆ in.). Los Angeles, J. Paul Getty Museum, 2019.111

The stiffened silk of the bodice creates a rigid-edged décolleté that frames the wearer's chest and shoulders. The tucker of lace peeking up above the plunging neckline adds a teasing nod to modesty.

95

Guide

Neckerchief A square of cloth folded in a triangle and tied around the neck, under or in place of a collar, with a square knot (SEE BANDANNA).

Stock Worn by men, a long strip of muslin, folded lengthwise, that wraps once or twice around the neck and is tied in the front; prior to the 1700s called a neckcloth. In the nineteenth century it was often paired with a high, stiff collar.

String tie A braided tie with aglets (SEE LACING/AGLET), placed under the collar and tied so that the ends dangle. The bolo, US Western-wear version, has a slide fastening.

Tie The conventional finishing element to a man's suit, often made of silk, that is run under the shirt collar and tied with a slip knot so that the ends lie one on top of the other. Introduced as sporting wear for men in the mid-nineteenth century, by the late nineteenth century the tie was adopted for uniforms, as a novelty accessory, and by women for leisure and active wear.

Tucker A band of fabric, often frilled or trimmed with lace, positioned under the neckline to add decorative effect or modesty.

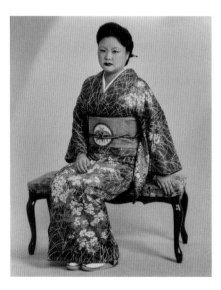

Tomoko Sawada (Japanese, b. 1977), *OMIAI* ♡, 2001. Chromogenic print, 46.4 × 36.7 cm (18¼ × 14⁷⁄₁₆ in.). Los Angeles, J. Paul Getty Museum, 2015.2.19, purchased with funds provided by the Photographs Council

Tomoko Sawada's series inspired by the initial exchange of photographs in an arranged marriage (*omiai*) presents herself as thirty individual characters differentiated by their dress. This traditional ensemble features a wide, golden obi tied with a darker gold *obijime*.

Obi

An artfully tied sash worn at the waist of a kimono. Replacing the ropelike cord used during the Heian period (794–1185), early obi were often hidden below a layer of the kimono. Over the course of the Edo period (1603–1867), obi gained in both decorative and symbolic importance, proclaiming the wearer's wealth, social rank, age, and marital status. A traditional obi is fifteen inches wide and four to six yards in length, made of embroidered silk or silk brocade, and usually lined with contrasting fabric.

It is folded lengthwise, wrapped twice around the waist with the fold facing downward, then tied in the back in any number of bows that are named for the shapes they suggest, such as butterfly, dangling, drum, iris, morning glory, or rose. Elaborate bows may be supported by a bustle-like pillow (*obimakura*) hidden under the loops. The front of the obi is arranged in soft folds that can be stiffened with inserted sticks (*obi-ita*). A decorative braided cord (*obijime*) is then tied around the obi and knotted either in front or in back. The obi finishes rather than secures the kimono, which is closed by hidden ties. The later Edo period saw the most elaborate forms and the greatest differentiation between men's and women's styles. Men also began to attach small box containers (*inro*) to carry items such as wax seals, medicine, and pipes. Attached to the obi with a braided cord, *inro* became another item for display, worn with elaborately—and often whimsically—carved ivory fasteners called netsuke.

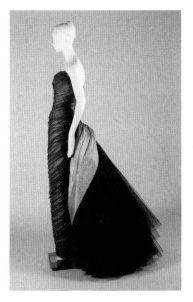

Charles James (British American, 1906–1978), Butterfly Ball Gown, ca. 1954. Silk chiffon, silk taffeta, and DuPont nylon net. Kent, OH, Kent State University Museum, Silverman/Rodgers Collection, KSUM 1983.1.412.

Charles James embedded support into the structure of this strapless sheath, hidden under a pleated chiffon overlay. The multicolored layers of the silk and net train are supported by plastic boning and a crinoline cone.

97

Overlay

A decorative layer of lace, mesh, or transparent fabric placed over a garment, especially the bodice or skirt of a gown. It may fit to the garment or float over it. The term may also refer to a panel of a different fabric—lace or something lighter—placed over part of a garment for decorative effect.

Padding

A layer of material inserted between the outer fabric and the lining to augment thickness, alter the silhouette (especially at the shoulders, chest, hips, or buttocks), or otherwise add structure, stability, size, warmth, or protection. From the later Middle Ages through the nineteenth century, bombast—a combination of discarded fabrics, horsehair, and even bran, encased in a fabric pouch or tube—was common (SEE BREECHES/TRUNK HOSE; SUPPORT/BUMROLL). Twentieth-century padding is made of a wide variety of synthetic fabrics. In Asia, through the nineteenth century, ARMOR

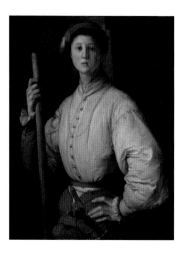

Pontormo (Jacopo Carucci) (Italian, 1494–1557), *Portrait of a Halberdier* (Francesco Guardi?), ca. 1529–30. Oil (or oil and tempera) on panel transferred to canvas, 95.3 x 73 cm (37½ × 28¾ in.). Los Angeles, J. Paul Getty Museum, 89.PA.49

Padding rounds out the torso and sleeves of this soldier's doublet (jacket). It creates a fashionable silhouette, augmenting his shoulders and chest while emphasizing his slender natural waist.

often had a protective padding of leather secured between layers of quilted cloth. Current typologies include Kevlar (in bulletproof vests), foam (in bicycling shorts), as well as layers of feathers, down, or synthetic insulation (in the quilted winter jackets sometimes called puffers).

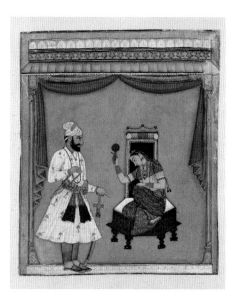

Basohli painting, *Standing Nobleman and Lady Holding a Mirror*, ca. 1700. Opaque watercolor and gold on paper, 18.3 × 15.4 cm (7³⁄₁₆ × 6 in.). London, Victoria & Albert Museum, South & South East Asia Collection, IS.30-1980

The Hindi term *jāma* can designate any garment, including this voluminous, long-sleeved coat with a yoke and crossover closing. "Pajama," a compound of the words leg (*pāy*) and garment (*jāma*), refers to the loose trousers worn beneath.

Pajamas

Loose trousers made of silk or cotton with a drawstring waist. The Hindi term *pāy-jāma* is a compound of the Persian words *pāy* (leg) and *jāma* (garment), and the type derives from garments traditionally worn by adults across South Asia and the Middle East. Loose and comfortable, pajamas were adopted by some European men while living in Asian countries, and then repurposed as part of a sleeping ensemble paired with a light jacket (SEE SLEEPWEAR/PAJAMAS). In the twentieth century, the term also designates very wide-legged trousers that are fitted through the waist and hips, worn by women as loungewear.

Passementerie

Decorative trimming whose name derives from the French *passement*, referring to metallic lace or braid, but may incorporate varied elements, including fringe, embroidery, beads, and/or metallic cords and threads. Narrow braid provides the core for the design. The ornaments may be linear, such as gimp or other braid, or point, such as rosettes, pom-poms, or tassels (SEE TRIMMING).

Pattern

The template for individual pieces of a garment that serves as a guide for cutting the fabric. Patterns are most commonly made of paper for the home sewer, with studier forms in cardboard or plastic used for professional production. Fine tailoring and couture design generally use a stable fabric such as calico or muslin to create pieces that fit an individual body. Commercially produced patterns, introduced to the public by Ebenezer Butterick in 1863 (men and boys) and 1866 (women and girls), are adjustable and have seam lines, darts, hems, and other construction features marked.

Peplum

A brief overskirt—anywhere from hip length to the top of the thighs—attached to the waistline of a gown or jacket as a decorative element, similar to a basque but made of a continuous piece of fabric, opening at the back or front to match the garment (SEE BASQUE; BODICE/BASQUE). It may be smooth and darted, gathered, or pleated into the waist seam. Although seen throughout history and across the globe, the peplum became particularly fashionable in women's wear from the 1930s through the 1950s, with a revival in the 1980s.

Pin

A small, pointed shaft, usually metal (a steel-nickel alloy or stainless steel), capped with a flat or rounded head. With a long history as a temporary fastener, pins are now most commonly used to hold pattern pieces to fabric during cutting or to secure the elements of a garment prior to stitching (SEE FASTENINGS AND CLOSURES).

Ballpoint pin (glass-point pin) A shaft crowned by a ball of plastic or glass that makes it easy to find during fitting and alteration.

Dressmaker pin (straight pin) A flat-topped, sharply pointed pin designed to leave a minimal mark in the fabric. It comes in varied lengths and widths.

Safety pin Two shafts joined by a simple spring device, with one shaft capped with a clasp. The pointed end of the other can be inserted into the fabric and then secured in the clasp. Derived from the ancient fibula, which lacked the spring, the modern safety pin was invented in the mid-nineteenth century.

Pinking

A series of closely spaced notches cut into the raw edge of a fabric. Named for the ruffled edge of the pink *Dianthus plumaris* in full bloom, pinking can be used for decorative effect or to keep a raw edge from raveling. Purpose-designed pinking shears were patented in 1934 by Samuel Briskman and made it possible to pink an edge with a single cut, as well as conventionalizing the now-common sawtooth pattern.

Placket

A reinforced opening at the end of a cuffed sleeve, the side of a gown, the top of a skirt or trousers, or the neckline (front or back), in the form of a panel or a band. It often hides such closures as buttons, snaps, or zippers, as in a side zipper, cuff placket, or trouser fly. The term also describes the reinforcing strip for shirtfront buttonholes.

Pleat

A fold of fabric—often in a series—that is secured on the upper edge but usually free at the lower edge. Pleating takes in excess fabric without losing movement and width in a garment, especially a skirt. Pleats take many forms; they may be pressed flat or left in soft folds, and can be stitched partway along the fold to create a smoother upper line. They are also used to introduce ease in a garment, as when inserted as a panel that expands when the wearer moves (SEE SKIRT/PLEATED SKIRT).

Accordion pleat A tight series of narrow, even, sharply pressed folds all around the garment, resembling the bellows of an accordion. When used in a skirt, it creates a zigzag contour at the hem and flows with the wearer's movements.

Box pleat In which the fabric is folded so that the edges are aligned on the inside of the garment and face in opposite directions on the outside to create a lengthwise, rectangular box. This pleat is often secured with stitching for a few inches along each fold. It may be pressed or left soft.

Flat pleat (knife pleat) A pleat series roughly an inch to an inch and a half apart, sharply pressed and all facing in the same direction.

Fortuny pleat Very narrow, closely spaced, irregular pleats created by a process invented by designer Mariano Fortuny y Madrazo (1871–1949) in 1909 for his Delphos and Peplos dresses. The pleats are initially hand stitched and then set in a damp heat process, which remains a secret. When the stitching is removed, the resulting effect is an elaborately crinkled, flexible fabric that clings to the body and undulates in movement. The pleats are refreshed by twisting the garment and rolling it into a circle for storage.

Arnold Genthe (American, 1869–1942),
Woman Wearing a Fortuny Dress, ca. 1920.
Gelatin silver print, 24.9 × 9.6 cm (9¹²⁄₁₆ ×
3¾ in.). Los Angeles, J. Paul Getty Museum,
84.XM.812.7

The Spanish designer Mariano Fortuny y
Madrazo combined a distinctive—and secret—
silk pleating process with silhouettes inspired
by ancient Greek garments. His Peplos design
floats a tunic fastened at the shoulders over
a columnar undergown that clings to the hips
and legs.

Inverted pleat The inverse of a box pleat
(SEE PLEAT/BOX PLEAT), with the edges of
the folds meeting on the outside of the
garment to create a lengthwise box on
the inside.

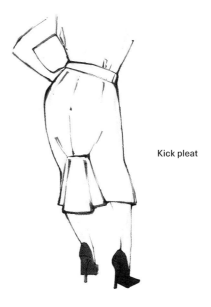

Kick pleat

Kick pleat A short panel of pleats
or a single pleat inserted in the lower
portion of the garment to facilitate
walking.

101

Kilt pleat A series of flat pleats all
folded in the same direction, with
each pleat edge covering roughly half
of the adjacent fold. Deriving from
the traditional method of folding
a KILT, these pleats may be used on
just a portion of a skirt, at the side
or the back.

Soft pleat Any type of unpressed
fold serving as a pleat.

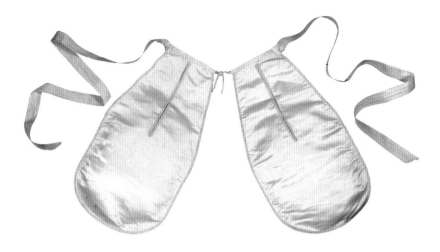

Pair of women's pockets, Great Britain, ca. 1760. Silk and hand-woven satin. London, Victoria & Albert Museum, T.175&A-1969, given by Mrs. J. Bentley

This pair of pockets, attached with a tape, would have been tied beneath a woman's skirt, hoops, and petticoats. The twill-edged slits lined up with openings in the skirt and undergarments for access.

Pocket

A fabric pouch worn under clothing or attached to a garment to hold personal effects. With origins in the fitchet—a slit in a TUNIC to allow the wearer to reach a bag worn on the body—pockets first appeared in Europe in the fifteenth century as a single pouch or pair of pouches attached to a cord and tied around the waist beneath the garment. By the sixteenth century, men's garments—particularly trunk hose and breeches—featured attached pockets accessible through an opening in a seam (SEE BREECHES/TRUNK HOSE). Pockets for women remained a separate garment—tied at the waist beneath the skirt and accessible through a seam opening or a PLACKET—until the mid-nineteenth century, when small pockets were attached at the waistline of the skirt. Pockets can be practical or decorative, with the basic forms including patch, set-in, and seam.

Bellows pocket A patch pocket, originally designed for hunting and sportswear, with folds of excess fabric along the three sewn sides to accommodate larger objects.

Flap pocket A set-in pocket with a separate panel of fabric at the top that covers the opening and may fasten with a button or a snap.

Patch pocket A pocket stitched to the outside of a garment for easy access and decorative effect.

Seam pocket A pocket accessed through a gap in the seam of a garment, sewn to the seam and usually made of a lighter fabric.

Set-in pocket A pocket created by cutting and clean finishing an opening on the outside of a garment; the pouch, made of a light fabric, is attached beneath it. The outer opening may be straight, curved, or slanted.

Welt pocket A set-in pocket with the lower edge finished from behind and a folded band of fabric (welt) that is visible on the outside through the opening. A double-welt pocket has folded bands on both the upper and lower edges. A welt may also also have a flap.

Puff

A rounded element created by gathering a piece of fabric at the top and bottom so that it appears inflated. It typically augments the top of a sleeve, but can be deployed elsewhere—at the waist, bust, back, or as a bustle—to add decorative fullness. Large sleeve puffs can be stiffened with an interlining or PADDED to hold their shape (SEE LINING/INTERLINING). "Puff" also refers to bits of lining fabric pulled out through decorative SLASHING.

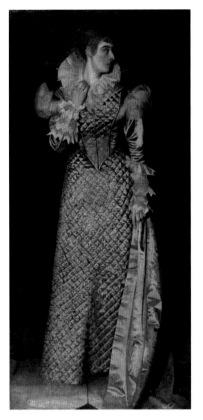

Walter Greaves (British, 1846–1930), *The Green Dress*, ca. 1875. Oil on canvas, 193 × 91.4 cm (76 × 36 in.). London, Tate Gallery, NO4599, presented by the Trustees of the Chantrey Bequest, 1931

Quilting gives the body of this garment opulence and structure. The elaborate sleeves, dagging-trimmed cuffs, and ruff suggest that it is a tea gown, or perhaps a costume for a fancy-dress ball.

103

Puttee

A long band of cloth wrapped in a tight spiral to cover the lower leg, named from the Hindi *paṭṭī*, meaning bandage, and adapted from the leggings worn by Himalayan tribesmen by armies throughout the British Commonwealth as well as in Europe. The bands were wrapped over woolen socks and the laced-up tops of the boots; during World War I the Imperial German Army used puttees to extend short boots up the lower leg to compensate for a shortage of leather. Japanese samurai and travelers wore a padded version made of cotton or linen for warmth as well as protection (SEE FOOTWEAR/SPAT; GAITER).

Quilting

A sewing technique in which two layers are joined—sometimes enclosing a filler layer—into a single layer secured with topstitching (SEE STITCH/TOPSTITCH).

Quilting strengthens and stiffens a fabric, and may be used to shape bodices, jackets, sleeves, and skirts. Quilted panels have been used to reinforce foundation garments (SEE CORSET). Depending upon the enclosed layer, quilting adds warmth, bulk, and even protection (SEE ARMOR). Almost any fabric can be quilted, even leather, and filler layers include batting (matted sheets of miscellaneous fibers), cotton, wool, feathers and down, and synthetics (SEE WAISTCOAT/DOWN VEST). Topstitched patterns in contrasting or metallic threads add a decorative effect.

Revers

The facing or lining of a jacket front or cuff exposed by folding back the edge of the element. The term is most commonly used in reference to lapels; strictly speaking, the revers are the revealed facings of the lapels (SEE COLLAR/REVERE COLLAR).

Ribbon

A narrow band of tightly woven fabric used for fastening, finishing, or trim with a SELVAGE on both lengthwise edges. Ribbons may be made of cotton, silk, or synthetics in a variety of weaves, with grosgrain (with a thicker weft creating a prominent cross rib) the most common. Ribbons are also worn as badges of distinction, affiliation, and support.

Cockade A flattened ribbon rosette with a button in the center worn on military uniforms or as a political insignia, as in the tricolor rosette worn by supporters of the French Revolution (1789–99).

Jacquard A ribbon featuring a woven or embroidered design.

Rosette A length of ribbon folded to resemble the petals of an open rose, worn on the breast or lapel as decoration or a badge of honor or affiliation; also used to decorate hats and shoes.

Satin ribbon A tight, smooth, shiny surface; the term refers to the weave rather than the textile.

Streamers Long ribbons attached to a garment on one end, with the other left free. Short streamers may be attached to the bottoms of badges. In seventeenth- and eighteenth-century European elite society, there was a fashion for children's garments featuring broad streamers at the shoulders, called "ribbons of childhood."

Velvet ribbon A tight weave with low pile on one side and and a plain weave on the other; the term refers to the weave rather than the textile.

Wassily Kandinsky (Russian, 1866–1944), *A Riding Amazon*, 1917. Oil on glass, 16 × 13 cm (6¼ × 5⅛ in.). Baku, National Art Museum of Azerbaijan

Wassily Kandinsky highlights the smartly tailored silhouette of a woman's riding habit; his title compares the athletic equestrienne to mythological female warriors. Breeches would replace the split skirt of the ensemble around the 1920s.

Riding habit

An ensemble worn for equestrian sports. While the elements vary with time and geographic origin, they share designs that provide ease of movement and protection. The conventional combination of cutaway back-vented jacket, breeches, knee boots, and hat, adapted from eighteenth-century European military uniforms, has varied over the centuries in response to prevailing fashion and changing decorum for women. To accommodate sidesaddle riding, for instance, women wore skirts with a substantial overlap. Split or safety skirts began to appear in the 1870s, often worn over some form of fitted trousers. During the first decades of the twentieth century, as women increasingly rode astride, riding breeches cut wide at the hips and tapered down the leg—paired with a long, back-vented jacket—replaced the split skirt. "Pinks" refer to the traditional scarlet coat worn for fox hunting featuring a black velvet collar, peaked lapels, and a back vent (SEE COAT/REDINGOTE; TROUSERS/JODHPURS).

Luisa Roldán (La Roldana) (Spanish, 1652–1706) and Tomás de Los Arcos (Spanish, 1661–unknown), *Saint Ginés de la Jara*, ca. 1692. Polychromed wood (pine and cedar) with glass eyes, 175.9 × 91.9 × 74 cm (69¼ × 36³⁄₁₆ × 29⅛ in.). Los Angeles, J. Paul Getty Museum, 85.SD.161

Saints and other biblical figures are often depicted in ecclesiastical robes. Here, the golden brocade of Saint Ginés's chasuble (the wide-sleeved robe) and dalmatic (the overgarment) strike a contrast with his bare feet, a traditional symbol of pious poverty.

Robe

A loose, full-length overgarment with many variations, worn throughout history. The term, first used in the Middle Ages to designate an individual's personal effects, today covers a very broad range of garments, including ceremonial, royal, clerical, academic, and conventional apparel. In Western cultures, the term also refers to intimate and informal garments, such as dressing gowns and cover-ups for sleep- or swimwear. Style lines vary widely, but most robes open in the front, have long sleeves, and end near the ankles.

Abaya A loose-fitting, full-length robe that pulls over the head, worn by women throughout the Arabian Gulf region. As modesty attire, it usually covers the wearer from neck to feet and is worn over a long skirt or loose trousers. The neckline is high, the sleeves are loose and long, and a side slit facilitates movement. The front may be embellished with embroidery, a partial button closure, or left plain.

Academic robe Worn in academic settings by those who possess or are receiving a degree. The loose robe is usually black, but it may have a color associated with the granting institution. Various styles of caps and hoods symbolize status and identity.

Banyan A loose, T-shaped overgarment based on South Asian and Turkish men's jackets, adapted into a dressing-gown style in Europe in the late seventeenth century.

Jacques Joseph (James) Tissot (French, 1836–1902), *Portrait of the Marquise de Miramon, née Thèrése Feuillant*, 1866. Oil on canvas, 128.3 × 77.2 cm (50½ × 30⅜ in.). Los Angeles, J. Paul Getty Museum, 2007.7

Designed to be worn in the boudoir over a nightdress, a peignoir often featured luxurious fabrics and trimming, as seen in this rose-pink velvet robe enriched with ruffles and a pelerine (cape).

Changpao A long gown worn over a skirt or trousers by men in the literati class in Qing dynasty China (1636–1912) (SEE *CHANGSHAN*).

Clerical robe Worn by ordained clergy, with the color and style, as well as ornaments and accessories, symbolizing religious affiliation, position, and liturgical purpose.

Dressing gown An intimate overgarment, worn only in private settings.

Negligee A woman's intimate overgarment, generally made of delicate fabric trimmed with ruffles and lace, worn exclusively in the bedroom and often designed with a matching nightgown.

Peignoir A woman's dressing gown, worn in private settings as a transitional garment from nightwear. Meaning "to comb" in French, the peignoir has its origins in the covering robes worn by women attending to their toilette in the seventeenth and eighteenth centuries.

Ruching

A fabric overlay manipulated with gathers, folds, or pleats into a rippled or ruffled effect that is stitched into place. It is commonly worked horizontally on either side of a seam, down the center of a BODICE front, or on the outer seam of a sleeve (SEE GATHER; OVERLAY; PLEAT; RUFFLE).

Nicolaes Eliasz Pickenoy (Dutch, 1588–1650/56), *Portrait of a Man*, 1632. Oil on panel, 121.9 × 85.1 cm (48 × 33½ in.). Los Angeles, J. Paul Getty Museum, 94.PB.1

A crisp, lace-edged ruff enhanced the restrained dress of successful merchants. After each wearing, the layers needed to be separated, washed, and then starched and re-pleated—skilled labor that not everyone could afford.

Ruff

A detachable starched and pleated collar worn by Europeans from the late fifteenth to the seventeenth century. The term "ruff" derives from the feathered frill that some male birds display during mating season. Ruffs varied in size and elaboration, but in general they were made of cotton, muslin, cambric linen, or lace, with cutwork or lace edging. A length of fabric was gathered or pleated into a ruffle with tubular folds, which were then starched, set on molding sticks, and shaped into a circle or crimped into place with a hot iron. The ruff was then attached to a neck band that was tied on, usually at the back, with finishing tassels. Elaborate ruffs had three or more layers, and most were white, but some were tinted during the starching process or enhanced with gold or silver threads. The most voluminous were supported with a wire frame (called a supportasse or underpropper) or sticks of ivory, wood, or bone inserted into the tubular folds. Removable and washable, ruffs kept the neckline of a garment clean; they were also believed to enhance posture and flatter the complexion. Requiring washing and setting after each wearing made them a luxury item that proclaimed wealth (SEE NECKLINE; RUFFLE).

Cabbage ruff (lettuce ruff) A ruff with irregular, loose folds resembling the leaves of a cabbage.

Cartwheel ruff (French ruff) A broad, stiffened, multilayered circle that stands out over the wearer's shoulders. The circumference ranges from a modest circle around the neck to beyond the breadth of the shoulder, with the widest worn almost exclusively by women.

Falling ruff An unstarched ruff that drapes over the shoulders in irregular folds, worn by men and women in England, and men in France, in the seventeenth century (SEE COLLAR/CAVALIER COLLAR).

Frizzle ruff A small, upstanding ruff worn in the seventeenth century.

Open ruff A large ruff, usually supported on a wire frame, that stands fanlike behind the wearer's head. It is open in the front, where it fastens. It was worn during the Elizabethan era (the second half of the sixteenth century) in England, and well into the seventeenth century in Spain (there called a *rebato*).

Ruffle
A band of fabric or lace, gathered at one lengthwise edge and attached to the garment so that the free edge has a rippled contour. Usually sewn to hems, cuffs, or necklines for decorative effect, ruffles can also be inserted in seams or arranged vertically on the front of an upper garment. The free edge is finished with a HEM or a band; a ruffle made of a strip of fabric folded lengthwise and gathered at the raw edge does not require a hem. It can also be PLEATED (SEE TRIMMING).

Double-edged ruffle A ruffle in which both lengthwise edges are hemmed, and the strip is gathered and attached down the center.

Flounce A ruffle created out of a circular strip of fabric, generally placed near the hem of a skirt, often in multiple rows.

Frill A small ruffle, usually double-edged.

Furbelow Refers to a skirt ruffle or a ruffle at the end of a scarf; by the mid-nineteenth century, a dismissive term for excess ornamentation

Sack (sac, sacque)
A garment designed to hang loosely around the body. "Sacque-back" refers to an eighteenth-century European trend in women's gowns that featured a full, flowing back silhouette created by gathering in the fabric at the neckline with two large box pleats—securely stitched from the neck band to the shoulders—with the rest of the fabric flowing freely and fully to the hem. A version of the form, renamed Watteau in reference to the French painter Jean-Antoine Watteau (1684–1721), who helped popularize the style in his work, was revived in the later nineteenth

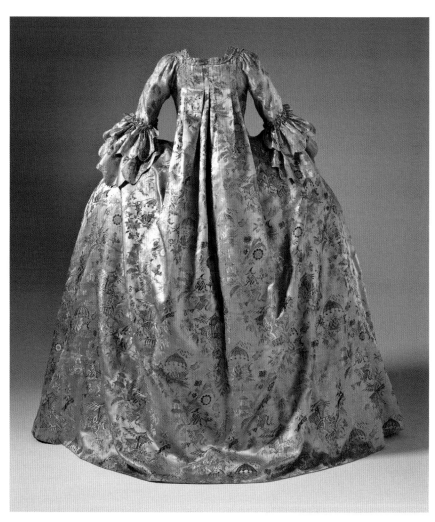

Robe à la française (back), the Netherlands, ca. 1740–50. Silk satin with silk and metallic-thread supplementary weft-float patterning. Los Angeles County Museum of Art, M.2007.211.928, purchased with funds provided by Suzanne A. Saperstein and Michael and Ellen Michelson, with additional funding from the Costume Council, the Edgerton Foundation, Gail and Gerald Oppenheimer, Maureen H. Shapiro, Grace Tsao, and Lenore and Richard Wayne

The box pleats of a sacque-back gown are secured by horizontal stitching across the upper bodice. The voluminous folds open to drape the remaining length and create a flowing silhouette.

century for tea gowns (SEE GOWN/TEA GOWN). The term "sack" also describes a new silhouette, introduced in the last third of the nineteenth century, for informal men's jackets featuring an unfitted silhouette without contour seams, waistline, or darts. In the twentieth century, the sack dress had several variations, including the TUNICS of the 1920s, the shifts of the 1960s that dropped straight from the shoulders to the hem, and most notably the haute couture sack dresses and coats of the 1950s, which tended to blouse in the back and taper toward the knees and calves.

Sari

A woman's outer garment made of a length of fabric that is artfully draped over a blouse and underskirt. Long associated with India's southern regions, a form of the sari appears in ancient tomb paintings, but its exact origins are obscure. Over time, regional styles developed throughout South Asia, with the twentieth-century Nivi style now most common. Saris are worn by women throughout society. The term specifically refers to a roughly six-yard length of cloth that is worn over a choli (SEE BLOUSE/CHOLI) and a columnar, drawstring skirt that sits just below the navel. Saris can be made of silk, light cotton, or synthetic material that is soft enough to drape. Starting at the front center, one end of the cloth is wrapped completely around the skirt with the top edge tucked firmly under the waistband. The other end is folded into soft pleats, circled once around the lower body, and then draped across the torso and trailed over the left shoulder. This free end (*pallu*) can hang over the shoulder, be carried across the forearm, or cover the head. The loose section, now hanging in front of the body, is hand pleated and tucked under the waistband. Hidden pins can be used to secure the sari at the hip or shoulder. The length of fabric can be edged with a contrasting and/or embellished border. Border embellishments may be very lavish, including beaten metal sequins, embroidery with *zari* thread (fine gold or silver), or yards of *kiran* (gold, fringed lace). Such saris serve as a sign of wealth, and all saris signify womanhood; girls wear simple dresses or *SHALWAR KAMEEZ*. Style and color mark the stages of a woman's life, from the extravagantly ornamented bridal sari and radiantly colored saris worn during a woman's fertile years to more subdued colors worn in middle age and plain white saris worn by widows.

Alice Neel (American, 1900–1984), *Woman*, 1966. Oil on canvas, 116.8 × 78.7 cm (46 × 31 in.). Courtesy the Estate of Alice Neel and David Zwirner

A sari combines draping and tailoring. The skirt is wrapped and hand pleated into a columnar silhouette with enough allowance for ease of movement. The *pallu* floats over the upper body, arranged to hide or reveal the snug-fit choli (blouse).

Sarong

A wrapped dress or skirt, made as a sewn tube with loose ends. Believed to originate among the seafaring people of the islands near Sumatra and Java, the garment was adopted throughout the Malay archipelago. The sarong is defined by its silhouette and lapped fabric; the wearer steps into the sewn column, pulls the loose ends taut around the body, and tucks or ties the ends to secure them. The fit, decoration, and manner of securing the ends reflect regional traditions. The sarong is sleeveless and strapless; one loose end may be draped over the shoulder. The popular, but inauthentic Western notion of a sarong as a tightly wrapped women's garment, without a sewn seam and intended to display the body, can be traced to Hollywood costume designs in the late 1930s, which, in turn, inspired beach and resort wear fashions.

Sash

A swath of cloth wrapped around the waist or draped diagonally from shoulder to hip. When used as a belt, the sash can be tied or looped to hold a garment closed or add a decorative effect (SEE BELT; OBI). When worn across the body, the sash is signatory—part of royal regalia or diplomatic dress, announcing military rank and affiliation, or conveying membership in an order such as the Légion d'honneur in France or the Order of the Garter in the United Kingdom. Sashes also are given in pageants, competitions, and academic commencement ceremonies; worn by scouts to display their achievement badges; and awarded in the martial arts in recognition of levels of expertise.

Scarf

A flat piece of fabric—square or oblong—with finished edges, worn for warmth or decorative effect. Scarves may be made of any fabric—silk, cotton, wool, synthetic—that is light enough to tie or drape. A scarf can be worn around the neck, head, or waist; arranged over the shoulders; or even fashioned into a simple top garment. As a fashion accessory, scarves often feature vivid colors and prints or an interesting texture; finishes include narrow hemming, fringe, decorative stitching, and light beads. Square scarves are often folded into a triangle to tie around the neck (SEE BANDANNA) or worn over the back and shoulders. There are an infinite number of ways to tie a scarf, and the manner itself is often regarded as an expression of individual taste.

Boa A long scarf with feathers, swansdown, or pleated silk attached along a round, narrow core.

Fichu A woman's triangular scarf, generally of sheer fabric or lace, worn over the shoulders and tied in the front or tucked into a décolleté bodice (SEE NECK-LINE/DÉCOLLETÉ).

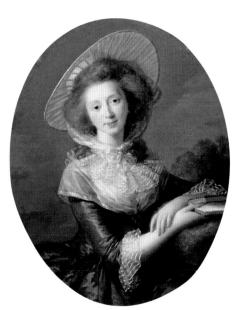

Élisabeth Louise Vigée Le Brun (French, 1755–1842), *The Vicomtesse de Vaudreuil*, 1785. Oil on panel, 83.2 × 64.8 cm (32¾ × 25½ in.). Los Angeles, J. Paul Getty Museum, 85.PB.443

A diaphanous fichu, secured with a tiny knot, covers the deep décolleté of the sitter's gown. Topped with a fine lace ruff-style collar, the ensemble strikes a playful balance between modesty and exposure.

Foulard A scarf of sturdy silk twill, often embellished with a small repeating pattern on a plain ground (a design with Indian origins).

Muffler A substantial oblong scarf—woven of wool, or knitted or crocheted—worn around the neck for warmth, and resting under or over a coat.

Ring scarf An oblong scarf with the ends attached to form a circle that is worn, often doubled, in a cowl around the neck; also called a cowl or infinity scarf.

Seam

Either a join created by stitching two or more layers of fabric together, or the line of stitching itself that secures the separately cut pieces of a garment. In a plain seam, sewn by hand or on a machine, the right sides (outsides) of the fabric are laid face to face and then stitched roughly five-eighths of an inch from the edge (the seam allowance). The raw edges of the seam allowance may be trimmed or finished in a variety of ways, for instance folded and stitched, overcast, enclosed in seam binding, pinked, or zigzagged (SEE STITCH). The seam allowance is then pressed to one side, or opened and pressed flat (open seam). Only the furrow created at the join is then visible on the right side.

Bound seam When the raw edges of a plain seam are enclosed in cut strips of the fabric, bias strips, or a purpose-made binding.

Clean stitched A narrow, folded hem along the raw edge of a pressed open seam.

Corded seam When, before stitching a plain seam, a cord encased in a bias strip is inserted into the join such that the cord follows the seam on the right (visible) side of the garment for a decorative effect.

Flat fell A very durable seam in which the undersides of the fabric pieces are placed together and sewn in place so that the raw edges appear on the right side of the garment. One edge of the seam allowance is trimmed to one eighth of an inch; the other edge is folded over the trimmed edge. The edges are pressed flat and stitched in place with two rows of stitching, sometimes in a contrasting color (SEE JEANS).

French seam A seam used for delicate and transparent fabrics in which the undersides of the fabric pieces are placed together and stitched so that the raw edges are on the right side. The allowance is then mostly trimmed off, and the fabric pieces are folded over the remaining raw edges and stitched in place, creating a narrow, enclosed seam on the inside.

Lapped seam A seam suitable only for very stable fabrics such as felt, denim, or tweed, in which one layer of fabric is laid so as to overlap another, both right-side up. They are topstitched together and the excess is trimmed.

Topstitched seam After pressing a plain seam on the inside, lines of stitching are run along the seam furrow on the right side to stabilize the seam or create a decorative effect; also called double stitched.

Selvage

The finished edge along the length of a woven fabric that prevents it from fraying, created during the weaving process when the weft thread is turned back for the next pass through the warp. The term derives from the Dutch *selfegghe* (self edge) and has been in use since the late Middle Ages. Given its distinctly different weave from the rest of the fabric, the selvage is often cut off or covered in garment construction, but it may also serve as a clean seam or hem edge.

Shalwar kameez

An ensemble of loose trousers and a long TUNIC worn throughout South and Central Asia. Believed to have evolved out of the distinctive attire associated with the Mughal era in India (the early sixteenth to the mid-eighteenth centuries), the tunic-style shirt (*kameez*) has side seams open from waist to hem and may have a standing, shirt, or band collar, or no collar at all (SEE COLLAR). The wide waist opening of the trousers (*shalwar*) is gathered with a drawstring or elastic; legs may be wide or narrow, and usually end in a turned cuff. The *shalwar kameez* is made of lightweight cotton or

silk, and the lines and fit allow ease of movement. Today, it is worn with a *dupatta* by women throughout India (SEE SHAWL/*DUPATTA*); it is worn by men in Afghanistan; and it is the national dress of Pakistan.

Archibald Motley Jr. (American, 1891–1981), *Mending Socks*, 1924. Oil on canvas, 111.4 × 101.6 cm (43⅞ × 40 in.). Chapel Hill, Ackland Art Museum, University of North Carolina, Burton Emmett Collection, 58.1.2801

A woven woolen square, folded into a triangle, warms the shoulders of this elderly woman. Her frilled apron and the cameo brooch securing her shawl project her decorous dignity as she carries out a mundane task.

Shawl

An oblong or square piece of fabric worn across the shoulders. A basic, utilitarian garment, the shawl has a long history, with roots that trace to South and West Asia. Shawls may be made of any fabric that will drape; square shawls are folded into a triangle and worn with the apex angle pointed down toward the waist. A pin may be used to fasten a shawl, or it may be worn loose, tied, or with one or both ends slung back over the shoulders. Larger than a SCARF and arranged more loosely than a WRAP, a shawl presents another example of DRAPED cloth design.

David Octavius Hill (Scottish, 1802–1870), Robert Adamson (Scottish, 1821–1848), and James Craig Annan (Scottish, 1864–1946), *Lady Mary Hamilton Ruthven*, negative ca. 1847; print ca. 1890. Photogravure, 20 × 14.9 cm (7⅞ × 5⅞ in.). Los Angeles, J. Paul Getty Museum, 84.XM.445.11

Made of diaphanous lace net trimmed with an equally delicate border, this large black shawl adds allure to a simple ensemble. Sheer as gossamer, it drapes but does not disguise the sitter's silhouette, as defined by her pose and tightly fitted gown.

Cashmere shawl Woven from the long, soft hair of Ladakhi goats of the Kashmir Valley, and exclusively worn by male courtiers serving the Mughal dynasty in the sixteenth through the eighteenth centuries. Distinguished by a fine, smooth weave that drapes like silk and featuring subtle colors and *boteh* (leaf or pine-cone pattern) on either end, these shawls became a highly desired, imported accessory for European women in the later eighteenth century. Genuine cashmere shawls remain a luxury item. They are now knit rather than woven, and the characteristic *boteh* design is no longer a feature.

Dupatta An all-purpose shawl with ancient Indian origins worn by women in South Asian cultures. The Hindi-Urdu term means "double-cloth." Most traditionally it is draped over the shoulders and the head, but when worn with a *SHALWAR KAMEEZ*, it is often just draped over one shoulder.

Paisley shawl A European shawl first produced in Paisley, Scotland, in 1808, as an affordable, Western version of the cashmere shawl. Made of coarser, heavier sheep's wool, it remained in fashion through the 1870s. It is typically decorated with a *boteh* pattern adapted from authentic cashmere shawls (called paisley) that elongates the traditional pine-cone and leaf forms with an an exaggerated emphasis on curvilinear movement.

Plaid A heavy, woolen, blanket-like shawl worn in the Scottish Highlands. Generally four to five yards long and two yards wide, the plaid is draped around the back and over the shoulders, and sometimes secured with a belt. A man's plaid extends to the knees, while a women's extends anywhere from the hips to the ankles. The term is derived from the Gaelic *plaide* (blanket) and also designates the range of patterns called tartans, composed of different-width stripes that cross at right angles.

Rebozo A very long, flat shawl with an extensive Indigenous history in Mexico. Rebozos have distinctive woven designs associated with regional traditions. Worn by women, they are wrapped around the upper body in a number of ways, providing warmth and head covering as well as decoration, or they may carry babies and bundles.

Serape A blanket-like oblong shawl tracing to ancient American cultures and worn by Indigenous peoples throughout South America, Central America, and the US Southwest, especially by men. The serape may be worn symmetrically or over one shoulder, and the colors and patterns reflect regional associations.

Stole A very narrow, very long band of silk worn by ordained Roman Catholic, Lutheran, and some Anglican clergy as part of ecclesiastical vestments, with colors that are specific to the liturgical occasion. The stole is also a fashion item loosely worn across the shoulders and often made of fur.

Shirring

Multiple rows of GATHERING stitches used to shape a garment through the torso, at the waist, or on the sleeves. This technique creates a decorative fullness above and below the stitching. Also known as gauging, machine shirring can use an elastic bobbin thread for a more flexible fit.

Shirt

An upper-body garment, covering the shoulders to the waist and below, generally with sleeves, and worn with great variations across the globe. In Europe, the term first emerged in the West during the Middle Ages to designate a long, loose undergarment pulled over the head. Over the centuries, the meaning narrowed to designate a more structured garment with a front fastening, worn mostly by men and closed left over right. It was adapted as women's wear in the late 1890s, fastened right over left.

Barong A buttonless shirt with a neck vent worn in the Philippines; sometimes richly embroidered.

Bib-front shirt A man's formal shirt with a bib-shaped inset, often pin-TUCKED (a narrow, stiched fold of less than a quarter inch).

Cowboy shirt US Western wear with a distinctive V-shaped yoke in back and front, featuring a convertible collar (SEE COLLAR/CONVERTIBLE COLLAR) and snap closures and worn with a bandanna, neckerchief, or string tie.

Dashiki With origins in Central Africa, a pullover shirt with an unfitted silhouette, loose sleeves, and no collar, often made of vividly printed fabric with a contrasting front panel. It may end anywhere from the hips to the ankles.

Dress shirt In Western cultures, the traditional button-front men's shirt with long, cuffed sleeves and a collar on a band, tucked into trousers and worn with a tie.

Marlon Brando as Stanley Kowalski in the screen adaptation of Tennessee Williams's play *A Streetcar Named Desire*.

When Marlon Brando displayed his muscular physique in a tight, thin cotton T-shirt in the 1951 film *A Streetcar Named Desire*, he transformed what had been a mundane undergarment into a symbol of male sensuality and rebellion.

John Singer Sargent (American, 1856–1925), *Mr. and Mrs. I. N. Phelps Stokes*, 1897. Oil on canvas, 214 × 101 cm (84¼ × 39¾ in.). New York, Metropolitan Museum of Art, 38.104, bequest of Edith Minturn Phelps Stokes (Mrs. I.N.), 1938

John Singer Sargent planned to portray Mrs. Phelps Stokes in an evening gown, but when she arrived for her sitting in a tailored walking ensemble—with a gray pleat-front shirtwaist and white detachable collar—he painted her as a "new woman" in sporting attire.

Dueling shirt A voluminous slip-on shirt with full sleeves, sometimes closed with a drawstring and worn with a long-ended stock (a strip of muslin, folded lengthwise, wrapped around the neck; SEE NECKWEAR/STOCK); also called a pirate or poet's shirt.

Guayabera A traditional style for men in Central America and the Caribbean, worn untucked and featuring a convertible collar (SEE COLLAR/CONVERTIBLE COLLAR) and four pockets—two on the yoke and two at the hip. It is generally embellished with pearl buttons and vertical pin TUCKS from the yoke to the hem.

Shirtwaist A tailored shirt adopted by women in the late nineteenth century and worn for sports and leisure.

T-shirt A twentieth-century pullover with a round neck and set-in sleeves made of cotton or synthetic knit, originally designed for men. The name refers to the silhouette of the garment when flattened.

Silhouette
The overall shape of an ensemble or a garment, without reference to STYLE LINES, construction lines, or ornamental details. Silhouettes emphasize how attire defines and displays the body at a particular moment in fashion history and are useful for understanding the expressive role of clothing of a specific time and place, especially in terms of identity, aesthetics, or gender.

Singlet
A one-piece, short-legged, stretchy garment worn for athletic activities. The spare design—low neck, no sleeves—and skintight fit make it suitable for such sports as wrestling, bicycling, and rowing. In the early twentieth century, men wore singlets for swimming. "Singlet" can also refer to a sleeveless U-neck top (SEE LEOTARD; SWIMWEAR; UNDERGARMENTS).

119

Skirt
A garment or element of a garment that covers the lower half of the body and lacks a division for the legs. A skirt may begin anywhere below the breast line and end at any point of the leg or flow onto the floor. Skirts have been worn throughout history and around the globe; during the Middle Ages in Europe, the skirt became associated with women, although men still wear skirts in some cultures and circumstances. Names of skirts often derive from their length (mini, midi, maxi), silhouette (straight, A-line, flared, full), or construction (bias, pleated, wrapped, yoke). The skirt is generally considered a separate garment, but the term can also describe the portion of a jacket, coat, or gown that extends below the waist (SEE GOWN; JACKET/FROCK COAT; KILT; ROBE).

Bouffant Any full skirt that is constructed of a rectangular piece or panels, gathered or pleated to fit the waist, leaving fullness over the hips; includes ballet, bell, and dirndl skirts (SEE SKIRT/DIRNDL).

Circle skirt In which the fabric is folded and cut in a semicircle so that the hem of the skirt is a full circle. This very full design flows smoothly over the hips.

Dirndl A full, gathered skirt that is traditional dress in Austrian, Bavarian, and Nordic agricultural communities.

Draped skirt A slim, often shaped silhouette with additional asymmetrical fullness pleated or gathered into a side seam.

Flared skirt A shaped skirt, closely fitted at the waist and over the hips, that flares out at the hem; also called a skater skirt. The silhouette is achieved using shaped panels or GORES.

Hobble skirt A skirt fitted to the waist, rounded at the hips, and then narrowing to the ankles. Although examples can be found throughout history, the term derives from an extreme form that restricted walking (hence the name) that was fashionable between 1910 and 1914.

Hoop skirt A full skirt supported from below with a hoop structure, stiffened crinoline, or wire inserted in the hem (SEE CAGE CRINOLINE; SUPPORT).

Overskirt An extra skirt or set of panels worn over a skirt for decorative effect, often featuring tabs, tapes, or ties to allow the wearer to loop up or drape the overskirt in an artful manner (SEE APRON/*TABLIER*).

Pleated skirt A skirt featuring any type of pleat, either pleated all around or partially pleated (SEE PLEAT).

Split skirt A skirt with some kind of bifurcation for movement or modesty (SEE CULOTTES; RIDING HABIT).

Tea-length skirt Generally a full skirt that falls three to four inches above the ankle, named in the 1920s for the decorous length of a woman's attire—neither sweeping the floor nor exposing her knees—when seated at a tea table.

Tie-back skirt Describes when front or side fullness, or the fullness of a train, is pulled up and secured with ties to form side puffs and/or drapes. It was popular from the mid-1860s to the turn of the twentieth century to accommodate changes in the fashionable silhouettes of skirts, from full to slim.

Tiered skirt A full skirt created from a series of increasingly wide circles, attached by gathering, so that the circumference of the hem is much wider than that of the waist.

LA MODA ELEGANTE ILUSTRADA

Ly 50.52.14
6 de Marzo de 1913

PRECIADOS 46

Nº 9

5166

Reproduction interdite

1913

Walking suits, from *La Mode Elegante Ilustrada*, 1913. New York, Metropolitan Museum of Art, b17520939, gift of Woodman Thompson

The slim silhouette of hobble skirts—fashionable from 1910 to 1914—often incorporated a pleat, a slit, or an overlay that allowed the wearer some freedom of movement, especially in ensembles designed for day-time strolls.

Guido Cagnacci (Italian, 1601–1663), *David with Head of Goliath*, ca. 1645–50. Oil on canvas, 108.3 × 86.4 cm (42⅝ × 34 in.). Los Angeles, J. Paul Getty Museum, 2008.43

Deliberate vertical slashes (panes) in David's teal-blue doublet expose glimpses of a white undershirt. This fashionable detail—intended to display fine fabrics—transforms the biblical hero into a contemporary aristocrat.

Slashing

A decorative technique in which the fabric of a garment is artfully cut to reveal the lining or an undergarment. Slashes, as seen in European court dress of the fifteenth through the early seventeenth centuries, could be arranged vertically, horizontally, or on the diagonal on sleeves, doublets, or gloves. Vertical slashes on sleeves or trunk hose are called panes (SEE BREECHES/TRUNK HOSE). For a luxurious display, the under fabric could be pulled out through the slash in a small puff.

Sleepwear

Clothing worn for sleeping and bed rest. Regarded as intimate apparel, sleepwear is generally worn in private: in the bedroom, for convalescence, and, more recently, for lounging. In many cultures, undergarments serve as sleepwear for men and women.

Bed jacket A waist-length covering garment for women, worn for eating breakfast in bed or receiving guests during convalescence.

Nightgown (nightdress) A loose, gown-like sleeping garment for women.

Nightshirt A sleeping gown—originally for men—that pulls over the head and has a rounded hem. It is based on a man's undershirt of the late eighteenth and nineteenth centuries, and worn in the later twentieth century by men or women.

Pajamas A sleeping ensemble of a jacket-cut top (often trimmed with piping) and loose trousers with an elastic or drawstring waist. Adapted from the traditional South Asian and Middle Eastern garment (SEE PAJAMAS), pajamas may have long or short sleeves and legs, be single or double breasted (or pull over the head), and tend to feature soft fabrics such as cotton, flannel, silk, or satin.

Bachiacca (Francesco Ubertini) (Italian, 1494–1557), *Portrait of a Woman with a Book of Music*, ca. 1540–45. Oil on panel, 103.2 × 80.3 cm (40⅝ × 31⅝ in.). Los Angeles, J. Paul Getty Museum, 78.PB.227

These spectacular sleeves have two separate elements: a puffed and padded upper sleeve made of the same rose silk as the gown, and a black velvet fur-trimmed lower sleeve. Laces or ties secured them to the gown at the armholes.

Sleeve

The element of a garment that covers the arm. Sleeves may be cut as part of the whole garment or constructed separately. Most commonly sewn into the garment, they can be designed to detach (SEE LACING). While sleeves are functional, providing warmth and modesty, they vary in contour, construction, and length, and can be imaginatively shaped and embellished.

Bishop sleeve A full, long, set-in sleeve, usually smooth at the shoulder cap and gathered into a band at the cuff.

Bracelet sleeve (three-quarters sleeve) A slim sleeve ending anywhere between the middle of the forearm and a few inches above the wrist.

Cap sleeve An extension of the upper-body garment covering only the curve of the shoulder.

Dolman Sleeve cut as part of the garment, with an under contour that traces a smooth curve starting near or above the waist and narrowing down the arm toward the wrist. When the arms are extended, the cut creates a cape-like or wing-like silhouette. Variants include batwing and butterfly.

Gigot (leg of mutton) A full-topped sleeve—sometimes lined or padded for volume—pleated or gathered into the ARMSCYE and tapering to the wrist, named for its resemblance to a mutton leg.

Juliet A puffed top, gathered into the cap of the ARMSCYE, joined to a slim sleeve that ends low on the wrist. It is named for Shakespeare's doomed heroine.

123

Guide

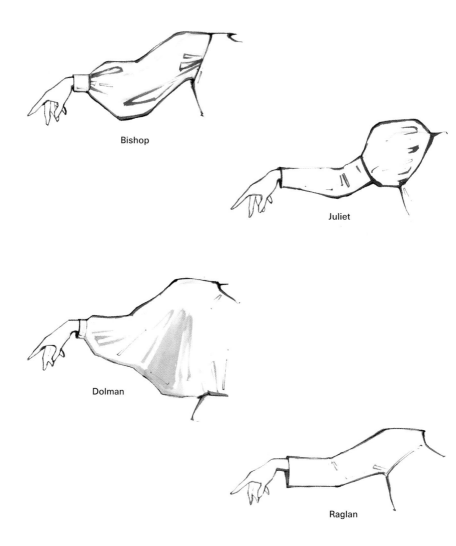

Bishop

Juliet

Dolman

Raglan

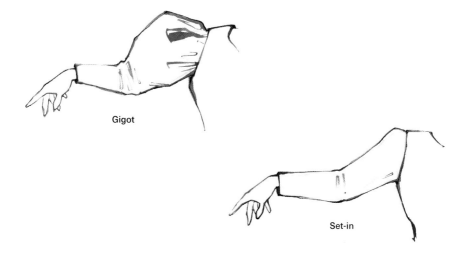

Gigot

Set-in

Kimono sleeve A long, full sleeve, cut as part of main garment, often featuring a hanging extension of the lower line (SEE KIMONO).

Puffed sleeve A sleeve of any length, cut full and gathered into the shoulder cap and at the cuff. The lower gather is secured by stitching, gathered into a band or separate cuff, or created by running elastic or a drawstring through a casing. Additional puffs can be created down the length of the sleeve for decorative effect.

Raglan A set-in sleeve with a seam that extends from the neckline to under the arm at the front and back. Smoothly covering the whole shoulder, it may feature a seam running down its outer line from the neckline to the cuff.

Separate (detachable) sleeve A separate element that is attached to the garment, usually with lacing, that can be created out of matching or contrasting fabric and facilitates both ease of movement and cleaning. It was most commonly seen on elaborate European garments from the later fifteenth to the seventeenth century.

Set-in sleeve Any form of sleeve that is sewn into the ARMSCYE.

Shirtsleeve A long, set-in sleeve, smooth at the shoulder cap and ending in a sewn-on cuff that closes with buttons or cuff links. A finely tailored sleeve, it has flat fell seams (SEE SEAM/FLAT FELL), one or two pleats, and a PLACKET opening at the cuff.

Suit sleeve Used on a jacket or other outer garment, a long sleeve constructed of two pieces—outer and inner arm—to allow ease of movement.

Slit

A deliberately placed SLASH in a garment to facilitate putting it on, to ease movement, or to expose a part of the body, most commonly placed in a slim skirt or the lower back of a jacket. A skirt may have a slit in the front, back, or side, or may have more than one slit. A slit may also be inserted into a PLEAT. A slit in the back of a garment is called a vent, and a jacket with two such slits that create an ease panel from somewhere above the waist to the hem is double-vented.

Smock

A long-sleeved, loose-fitting worker's overgarment meant to protect clothing. It may open in the back or front, is usually knee length or shorter, and may have large pockets and a broad, flat collar. In the European Middle Ages, "smock" referred to a woman's undergarment (SEE CHEMISE), but by the eighteenth century, the term designated the voluminous jacket worn by male agricultural workers. The extra fabric in the arms and body of a "smock frock" (facilitating ease of motion) was often secured with tight, even pleats and decorative stitching (SEE SMOCKING). Smocks, often featuring a YOKE, were also worn by children around this time, and in the later nineteenth century, women adopted various forms of the smock as decorative leisure wear (SEE GOWN/TEA GOWN). The smock remains a utility garment associated with a number of professions, including housework, factory work, craft work, and the arts.

Georges Achille-Fould (French, 1865–1951), *Rosa Bonheur in Her Studio*, 1893. Oil on canvas, 91 × 124 cm (35¾ × 48¾ in.). France, Musée des Beaux-Arts de Bordeaux, Bx E 946

In defiance of a ban that dictated gendered dress in France, Rosa Bonheur (1822–1899) wore a workingman's smock and trousers when she painted. She had to carry a *permission de travestissement* to avoid arrest for wearing male attire. The ban was not lifted until 2013.

Smocking

A needlework technique in which small, tight stitches secure rows of gathers on a panel of cloth in a honeycomb pattern. With origins in the decorative stitching used to fasten the ease pleats in a worker's smock (SEE SMOCK), by the mid-nineteenth century smocking embellished the sleeves and decorative inserts at the yoke of women's garments and became a characteristic feature of infants' YOKED gowns.

Stitch

A loop produced by passing a threaded needle in and out of a piece of fabric—the basic building block of sewing. Made by hand or machine, a series of stitches—usually of the same size and regularly spaced—join, shape, and secure individual pieces of a garment (SEE GATHER; HEM; SEAM; SHIRRING). Stitches may also be used to decorate the surface of a garment (SEE EMBROIDERY; SMOCKING) and in knitting and crochet work. Both tailoring and dressmaking involve a varied repertoire of stitches.

Backstitch To pass the needle back through the point of the last stitch to begin the next one, creating a running line that resembles machine stitching. On a machine, this refers to reversing back over a line of stitches to secure the end.

Bar tack Closely spaced, parallel stitches that reinforce the end of an opening such as a buttonhole.

Basting A line of long running stitches, made by machine or by hand, that temporarily joins the pieces of a garment during construction and is removed when the final seams are sewn (SEE STITCH/RUNNING STITCH).

Blanket stitch Closely spaced, connected, overcast stitches in which the needle is passed through the top of the stitch before making the next one to create a clean edge (SEE STITCH/ OVERCAST STITCH). This is an edging technique for hems, collars, and cuffs, and to enclose buttonholes.

Blind stitch A small stitch worked under a fold or between layers that does not pierce the outside of the fabric. It is meant to be hidden and often used to hem fine garments.

Overcast stitch Even, diagonal stiches commonly used for hemming that are sewn over the edge of an element to secure a fold of fabric or prevent fraying.

Padding stitch A long stitch, repeated in a diagonal or V-shaped pattern, used to hold interlining in place (SEE LINING/INTERLINING).

Running stitch A series of even, closely spaced stitches used for seams, gathers, tucks, and quilting; the most basic stitch in garment construction.

Tack A loose, hidden stitch used to join one layer of fabric to another.

Topstitch A line of machine stitching visible on the right side of a garment that secures a seam or decorates the surface.

Whip stitch A simple running stitch encasing the edge of the fabric to prevent raveling.

Zigzag A machine stitch running side to side in a sawtooth pattern at the fabric edge to prevent raveling.

Nicolaes Eliasz Pickenoy (Dutch, 1588–1650/56), *Portrait of a Woman*, 1632. Oil on panel, 118.7 × 91.1 cm (46¾ × 35⅞ in.). Los Angeles, J. Paul Getty Museum, 54.PB.3, gift of J. Paul Getty

Stomacher

A panel, inserted into or worn on top of the upper garment front. As worn by women, and occasionally men, in Europe from the later fifteenth to the seventeenth century, the triangular-shaped stomacher was positioned below the breasts and filled in the front of the bodice or doublet to the waist, or even below. Stomachers were stiffened with boning or lining, and stitched, pinned, or laced in place, and since they were meant to be seen, they were embellished with embroidery, metallic threads, and pearls. They are also called a placard, placket, or plastron (SEE GOWN/MANTUA; JACKET/DOUBLET).

More than just a decorative addition to a simple gown, this magnificently embroidered stomacher likely covers the bodice lacing and fans out at the waist to flatten the fullness of the skirt front.

Style lines

The particular seams and features of a garment that are distinctive to the garment's date, origin, and (in some cases) gender, for instance neckline, waistline, ARMSCYE, and length of elements, as well as those that are both functional and decorative, as in cuffs, collars, and fastenings. Along with the SILHOUETTE, style lines situate a garment in fashion history.

Francisco de Goya y Lucientes (Spanish, 1746–1828), *Manuel Osorio Manrique de Zuñiga*, 1787–88. Oil on canvas, 127 × 101.6 cm (50 × 40 in.). New York, Metropolitan Museum of Art, the Jules Bache Collection, 1949, 49.7.41

Skeleton suits, consisting of a jacket buttoned to the pants at the waist, were worn by boys considered too old for an infant's frock but too young for masculine attire. Most had back panels to facilitate changing undergarments.

Suit

An ensemble of items of apparel coordinated through style lines and fabric, which may match or contrast. The suit may consist of a jacket and trousers (or skirt) with additional elements such as a waistcoat and accessories. While coordinated ensembles are seen in national dress across the globe (SEE *HANBOK*; KIMONO; *SHALWAR KAMEEZ*), the European origins of the suit trace to the emergence of the justaucorps—a matching set of jacket, breeches, and waistcoat—in the seventeenth century. In the next century, the justaucorps (meaning close to the body), tailored to fit an individual, became the standard menswear ensemble, and by the late eighteenth century, the term "suit" came into use to designate a matched ensemble of jacket and trousers of any style (SEE JACKET; WAISTCOAT). In the twentieth century, the terms "skirt suit" and "pantsuit" came into use for women's wear.

> Ditto suit Used in the eighteenth and nineteenth centuries to indicate elements made of the same fabric. Since the mid-nineteenth century, it has referred to an informal ensemble of this type made of patterned fabric.
>
> Lounge suit A British term from the mid-nineteenth century forward for an informal suit without a waistcoat. It usually features a SACK jacket and trousers in matching fabric, and can be worn with a waistcoat that is coordinated but not designed as part of the ensemble. The mid-twentieth-century version consists of just a jacket and trousers, and is called a "leisure suit" in the United States.

Skeleton suit A high-waisted two-piece garment for small boys (toddlers through six or seven years) worn in Western cultures from the late eighteenth through the early nineteenth centuries. Seen as an interim garment between the genderless dress of infancy and the miniature menswear for growing boys, skeleton suits were often made in bright colors (especially red), with low necklines trimmed with a RUFFLED or lace collar. The high-waisted trousers buttoned to the hem of the jacket, with a sash covering the fastening to give the appearance of a single garment. The trousers often featured a back-buttoned panel for convenience.

Tamara de Lempicka (Polish, 1898–1980), *Portrait of the Marquis d'Afflito*, 1925. Oil on canvas, 82.6 × 132.5 cm (32½ × 52³⁄₁₆ in.). Private collection

Initially designed as an informal alternative to evening wear, a bespoke tuxedo marked the epitome of masculine style in the 1920s. The contrasting satin lapels and stripes along the outer lines of the trousers contribute to the illusion of a sleek, elongated silhouette.

Tuxedo Combining a fingertip-length dinner jacket, trousers with a satin side stripe, a cummerbund, and a bow tie, sometimes paired with a tuck-front shirt with a standing winged collar. The tuxedo was introduced in the late nineteenth century as informal evening wear (SEE JACKET/DINNER JACKET). The name derives from a breach of decorum that occurred in 1886 when US tobacco magnate Griswold P. Lorillard and his son wore the informal ensemble to the annual Autumn Ball in Tuxedo Park, New York. In the twentieth century, tuxedos generally all became either black or midnight blue (although with a white jacket and black trousers for summer wear) and are today regarded as formal evening wear for men and, more recently, women.

Zhongshan suit A twentieth-century Chinese suit, based on the contemporary Japanese military cadet uniform, introduced as an alternative to the Western business suit during the early years of the Republic of China (1912–49), featuring

a TUNIC jacket with a high, buttoned, convertible collar (SEE COLLAR/CONVERTIBLE COLLAR), four front pockets, and matching trousers. After the Revolution of 1949, the suit gained even greater significance, as it was worn by Mao Zedong and adopted by his followers—male and female—as a demonstration of anti-Western, proletarian unity (SEE JACKET/MAO JACKET).

Zoot suit A loose-fitting suit with an exaggerated silhouette, particularly through the shoulders, waist, and lapels. Voluminous trousers are pleated into a fitted waist and tapered to a tight ankle, and the look is finished with a prominent watch chain dangling from the waist. A distinctly US fashion associated with hip culture after World War II, the ensemble merged a number of street-wear styles, including those of young Mexican American men in Los Angeles and jazz musicians in New York.

Maerten de Vos (Netherlandish, 1532–1603), *The Vanity of Women, Masks and Bustles*, ca. 1600. Engraved paper. New York, Metropolitan Museum of Art, 2001.3411, purchase, Irene Lewisohn Trust Gift, 2001

Tied over the underskirt and hidden beneath the draping of overskirts, the stuffed-cloth tube of a bumroll simulated the silhouette of the rigid farthingale (wheel-shaped hoop) by accentuating the waist and augmenting the hips.

Support

A material, element, or technique used to reinforce and retain the shape of apparel, for instance to augment the silhouette, define style lines, add rigidity to a form, or reinforce fabric at points of strain. It may be sewn in, detachable, or worn along with or under the garment. It also may be used to shape the form of the body (SEE CORSET; CRINOLINE; LINING; UNDERGARMENTS/BRASSIERE; UNDERGARMENTS/GIRDLE).

Backing An extra layer applied to the backside of the fabric for reinforcement (SEE LINING/UNDERLINING).

Boning A rod of baleen (whalebone), caning, cork, quill, metal, plastic, or other such material inserted in a seam or casing to act as an armature for the desired shape, particularly in a corset or bodice (SEE NECKLINE/STRAPLESS). Flexibility in the material is preferred.

Buckram A stiff cotton with a loose weave strengthened with a sizing agent such as starch or glue. It can be molded when wet, and holds a rigid shape when it dries.

Bumroll A cloth tube, padded with horsehair and fabric scraps, tied around the waist to support the top of the skirt.

Horsehair A stiffening fabric woven with a cotton warp and horsehair weft (now mostly synthetic) used in tailoring to shape shoulders, reinforce the collar and lapels, or provide a stable interlining beneath buttons and buttonholes. Prior to the CAGE CRINOLINE, horsehair was used for petticoats to augment full skirts.

Suspenders (braces)

A pair of detachable leather, elastic, or webbing shoulder straps that fasten to the waistband to support trousers. The straps are separate in the front but may cross or converge into one strap in the back. Fasteners include clips, clasps, and buttons; braces (the preferred British term) always have buttons. First popular in the later eighteenth century, suspenders survive in menswear, notably in finely tailored suits and rural dress, but can be worn by women as well. The term can also refer to skirt straps or a bib top on a child's garment, as well as straps attached to a support undergarment to secure stockings (SEE UNDERGARMENTS/GARTER BELT).

Swaddling clothes

Long strips of fabric, often flannel or soft linen, wrapped around an infant's body, restraining their legs and often their arms and believed to serve a calming function; often also believed to align and strengthen limbs. Practiced in cultures all over the world, swaddling in Central Asia dates back as early as 4000 BCE. In Western culture, the practice declined through the eighteenth century. In many Indigenous cultures, a form of blanket swaddling secures babies on cradle boards for transportation.

Sweater (jumper)

A knitted or crocheted garment for the upper body. The earliest known versions trace to the English Channel Isles in the form of woolen TUNICS for fishermen; the sheep's wool maintains a high level of natural oil that repels water. Decorative effects can be created through stitch patterns or by using different-colored strands of yarn. A warm, often supple garment with infinitely varying STYLE LINES, sweaters exist in distinctive versions wherever knitting or crochet is practiced.

Cardigan A jacket-like garment with a front button closure. It is named for James Brudenell, Seventh Earl of Cardigan, who wore a knitted layer under his tunic to ward off the chill on the battlefields during the Crimean War (1853–56).

Fisherman's sweater A bulky, hand-knitted pullover made of natural, undyed yarn with a high oil content. Stitch patterns—cables, seeds, bobbles—provide warming bulk as well as decorative effects.

Jersey A fine machine knit first used in the mid-nineteenth century for men's athletic wear and undergarments. It became fashionable in the twentieth century,

Gerald Leslie Brockhurst (British, 1890–1978), *Jeunesse dorée (Kathleen Woodward)*, 1934. Oil on board, 76.2 cm × 63.1 cm (30 × 24¹³⁄₁₆ in.). Port Sunlight, Liverpool, England, Lady Lever Art Gallery, National Museum, LL3908, purchased by William Hulme Lever for the Lady Lever Art Gallery in 1934. © Richard Woodward

With humble origins as a warming garment, sweaters became fashionable in the twentieth century. Here, rib stitching on the sleeves and at the waist makes the usually boxy cardigan more form fitting.

especially for women, for its drape and flexibility. It is named for the isle of Jersey in the Channel Islands, where the practice of knitting such sweaters is believed to have originated, and is handled like a woven textile, with garment pieces cut from lengths of fabric rather than knitted into the final form.

Pullover A sweater that pulls on over the head; it may have a shoulder opening that fastens with buttons. NECKLINES include crew, bateau, turtleneck, and V neck. The sleeve length varies, and shoulder lines include set-in and raglan sleeves (SEE SLEEVE/RAGLAN).

Twin set A pair of matching sweaters—a cardigan with sleeves and a sleeveless shell—designed to be worn together.

Swimwear

Clothing designed for swimming and seaside sports. Traditionally, in most cultures, light clothing or underwear served as swimwear. Men, and occasionally women (usually bathing separately), also swam nude. With the rise of mixed swimming in Western cultures in the mid-nineteenth century, women's costumes came to consist of a simple bodice with a knee-length skirt over ankle-length trousers, while men wore slim-fitting drawers and pullover tops. Both costumes were made of wool, with men's sometimes made of jersey. Through the early decades of the twentieth century, evolving textile technologies and changing attitudes about modesty and physical display led to better fit, stabler shapes, and increased exposure of the body, although retaining the convention of covering the genitals and women's breasts.

Bikini A two-piece suit for women that exposes the navel. Originally named "the atom" for its size, the better-known name refers to the Bikini Atoll, the site of atomic experiments (1946–58) in the Marshall Islands.

William Claxton (American, 1927–2008), *Peggy Moffitt Modeling the Topless Swimsuit Designed by Rudi Gernreich*, 1964. Gelatin silver print. The William Claxton Estate

Rudi Gernreich initially conceived the monokini as a pioneeringly unisex garment, but the style, modeled here by 1960s style icon Peggy Moffitt, was sensationalized as the "topless swimsuit" in the press.

Maillot A one-piece suit made of stretchy fabric and supported by straps for women (SEE LEOTARD). It differs from a tank suit in that it often includes support for the breasts and a straight-cut or shaped rather than scooped neckline. The straps are commonly separate, attached elements rather than cut as part of the neckline.

Monokini A one-piece women's suit that exposes the breasts, designed by Rudi Gernreich in 1964, with a high-cut waist and two straps that are separated in the back but meet in a V in the front. Also called the "topless," it never caught on as anything more than a novelty.

Speedo A tight-fitting, very brief man's suit, its name taken from a snug nylon suit designed in 1955 by MacRae Knitting Mills of Australia for Olympic competition.

Tank suit Originally a one-piece, short-sleeved or sleeveless man's suit with short legs resembling a LEOTARD or maillot (SEE SWIMWEAR/MAILLOT). The term now also applies to a very simple woman's suit with a deep scoop neck and minimal support for the breasts.

Trunks A loose-fitting man's suit with an elasticized or drawstring waist and legs that partially cover the thigh but end above the knee. Board shorts—a longer, baggier, unlined variation—were originally designed for surfing.

Tabard

A simple upper-body garment created out of a front and a back panel. It is usually sleeveless, joined at the shoulders but open at the sides, and pulls over the head. The basic form traces back to any number of ancient cultures. During the Middle Ages, tabards were worn over ARMOR and decorated with heraldic devices to proclaim

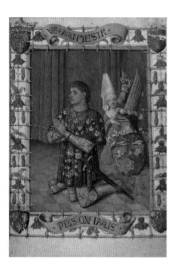

Jean Fouquet (French, ca. 1420–1481), *Simon de Varie Kneeling in Prayer,* from the *Hours of Simon de Varie*, 1455. Tempera colors, gold paint, gold leaf, and ink, 11.4 × 8.3 cm (4½ × 3¼ in.). Los Angeles, J. Paul Getty Museum, Ms. 7 (85.ML.27), fol. 2, partial gift of Gerald F. Borrman

In medieval Europe, emblazoned tabards proclaimed a knight's lineage or alliance with a court. Here, Simon de Varie, who rose from the merchant class to a position in the royal treasury, wears the French monarchy's fleur-de-lis.

identity or allegiance. They were also worn by heralds at tournaments. Now they are a protective garment, often made of disposable fabric, worn for catering, cleaning, or health care, or as a swimsuit cover-up.

Giovanni Battista Moroni (Italian, 1520/24–1579), *The Tailor*, 1565–70. Oil on canvas, 99.5 × 77 cm (39³⁄₁₆ × 30⁵⁄₁₆ in.). London, National Gallery, NG697

The scissors in one hand and length of cloth in the other identify this man as a tailor. His doublet, with sleeves, torso, and collar band cut and sewn to measure, demonstrates the distinctive quality of his craft.

Tailoring

A set of construction techniques that shape a garment through cutting fabric to size and seaming the pieces. In contrast to draped or wrapped garments—formed out of lengths of fabric that are fluidly arranged on the body—tailored garments use cut, fit, and finishing to follow the body's distinct contours. The structure is part of the design. Derived from the French *tailler* (to cut) and traceable to European medieval craft guilds, tailoring has long been associated with men's dress in Western culture. Over the centuries, women's tailored garments have included coats, suits, riding habits, and uniforms. In contemporary use, tailoring designates structured garments for all genders—often clean-lined or severe—as well as made-to-measure custom clothing (SEE COAT; JACKET; RIDING HABIT; SUIT).

Toga

An outer garment worn in ancient Mediterranean cultures, notably Rome. In the basic Roman form, the straight edge of a large, semicircular piece of white wool is centered on the front of the body and one end is draped over the left shoulder. The loose end is then brought across the back and under the right arm, then draped diagonally across the chest to rest over the left shoulder. A TUNIC was usually beneath it. The toga was worn by free male citizens during the Republican era (509–27 BCE), and decoration distinguished rank during the Imperial era (27 BCE–476 CE). The term now loosely refers to a wrapped garment with one end carried over the shoulder.

Train

An elongated section at the back of a skirt that may be cut as part of the garment or attached as an overlying panel. A train extends the back profile of the skirt beyond that of the front and trails on the ground as the wearer moves. It can be attached at the waist or the shoulders, and the length varies with style and occasion. Length has also been used in ceremonial settings to indicate rank. Today, trains are worn as evening and bridal wear, as court dress, and on some academic and ceremonial robes. Common lengths in bridal wear are the ten-inch "sweep," the two-foot "court" train, the three-foot "chapel" train, and the six-foot "cathedral" train.

135

Guide

Yinka Shonibare, CBE (British-Nigerian, b. 1962), *Big Boy*, 2002. Wax-printed cotton fabric and fiberglass, 215 × 170 × 140 cm (84 × 66 × 55 in.). Art Institute of Chicago, 2004.759, gift of Susan and Lewis Manilow

Challenging historic style and gendered dress, Yinka Shonibare incorporates a sweeping swallowtail train into the lines of a conventional Victorian frock coat. The whole of the ensemble was fabricated in wax-resist batik cloth of the type created by the Dutch and marketed throughout West Africa in the 1800s.

Trimming

Element attached to a garment for ornamentation. It can be made of the same material or, more typically, something enriching such as ribbon, lace, contrasting fabrics, or silk or metallic thread. Trimming positioned to hide the raw edge of a fabric is called edging (SEE BIAS; BRAID; PASSEMENTERIE; PINKING; STITCH/TOPSTITCH).

Fraying Separating the threads of a garment edge to simulate wear for a decorative effect. This works best with soft, loose weaves such as linen or cotton.

Fringe Parallel threads attached at the top by a narrow band. The threads may be of any length, straight or twisted, or made of fabric or leather cut into narrow strips.

Galloon A wide, flat braid, often incorporating gold or silver thread, typically used on military uniforms and ecclesiastical garments.

Gimp A braided ornamental trim that incorporates a wire, metal thread, or central cord for structure.

Piping A narrow strip of fabric folded into a tube and stitched in place. It may be rounded or pressed flat, encase a cord for definition, or be made of bias strips.

Pom-pom A cluster of yarn, thread, or feathers formed into a ball. Pom-poms are most commonly used on hats, but small ones can be attached to garments as ornaments.

Rickrack A flat, braided, linear trim in a zigzag form.

Rosette Lace, ribbon, or fabric formed into the shape of a rose; may also be made of leather, especially to trim a shoe. It may be three-dimensional or pressed to lie flat.

Soutache A flat, narrow braid worked in a herringbone pattern around two parallel cords and made of silk or wool. It is machine attached in outline patterns that often feature curved elements.

Tassel A cluster of loose threads cut to an even length and bound together at the top with stitching, ornamental cording, or knotting.

Trousers (pants)

A bifurcated garment that covers the lower body, usually from waist to ankles. The term derives from the Scotch-Irish *trewes* (combined breeches and stockings) and refers to "a pair" of trousers in that there are two legs; the singular may be used for specific reference to a part of the garment, as in the "left trouser leg." Trousers vary widely in length, volume, waist design, fastening, and hems, and are worn across the globe, although Western cultures regarded them as a specifically male garment until the twentieth century (SEE BREECHES; CULOTTES; JEANS; PAJAMAS).

Jean-François Millet (French, 1814–1875), *Man with a Hoe*, 1860–62. Oil on canvas, 81.9 × 100.3 cm (32¼ × 39½ in.). Los Angeles, J. Paul Getty Museum, 85.PA.114

Over the centuries, European agricultural laborers wore trousers to protect their legs; until the nineteenth century, higher-status men wore leggings and breeches. Like his plain shirt and wooden footwear, this worker's trousers are serviceable and well worn.

Bell-bottoms Pants that are smooth over the hips and widen to a full bell shape from the knee to the ankle. Worn by British sailors, they were adapted as a fashion trend for men and women several times over the twentieth century.

Chaps A protective covering for the fronts and sides of the legs, worn over trousers, especially for riding horses, often made of leather or buckskin.

Chooridars Pants that are full cut through hips and thighs, but narrowing from the knee to the ankle with extra length that is pushed up to create rumpled folds. It is a man's garment with Indian origins.

Cossack (*sharovany*) Peg-topped, full-length trousers with a single or double strap around the instep to secure the leg. It has origins in Russia and Eastern Europe.

Dhoti Trousers draped from a generous length of fabric that encases each leg and is drawn up between them and secured by tucking into a waistband. The fabric is tight around the lower leg, with excess fabric forming U-shaped swags in the front and back. The term derives from a Sanskrit word meaning "to cleanse."

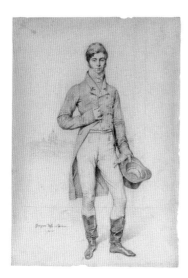

Jean-Auguste-Dominique Ingres (French, 1780–1867), *Portrait of Lord Grantham*, 1816. Graphite on substrate, 40.5 × 28.3 cm (15¹⁵⁄₁₆ × 11⅛ in.). Los Angeles, J. Paul Getty Museum, 82.GD.106

Trousers favored by fashionable European men during the first decades of the nineteenth century closed with a fall (drop panel) in front that buttoned on either side. Trouser straps secured the hems under the instep, creating a smooth, taut silhouette.

Fly The front closure of the pants, initially conceived to allow men to urinate without removing their trousers. It may be covered with a dropped panel (or fall), secured with buttons, or closed with buttons, laces, or a zipper hidden under a PLACKET. It is today the conventional opening for tailored pants (SEE FASTENINGS AND CLOSURES/FLY FRONT).

Gaucho pants Calf-length trousers, slim at the hips and cut wide at the hem, associated with South American cattle farmers and horsemen. They are traditionally made of leather.

Harem pants Very full-cut trousers, gathered in at the waist and ankles, copied from Near and Middle Eastern styles.

Jodhpurs Riding pants cut full at the hips and thighs, with fitted lower legs that end in a cuff, adapted as European equestrian wear from Indian *chooridars* (SEE TROUSERS/*CHOORIDARS*; RIDING HABIT).

Knickerbockers Full trousers ending below the knee with the hem gathered into a close-fitting band, resulting in a bloused shape, worn by men for country sports and golf since the mid-nineteenth century, and by schoolboys (knickers) in the late nineteenth and early twentieth centuries. Plus-fours have a similar design but are longer, having four additional inches below the knee.

Shorts Any style trousers that end somewhere between the upper thigh and above the knee. Originally an athletic garment in Western cultures, particularly for men, shorts became fashionable as leisure wear—and as a way to display the body—in the twentieth century.

Stovepipe pants Pants with a straight-cut leg, roughly the same width from thigh to ankle. They first became fashionable as part of a man's ensemble in

Ruth Harriet Louise (American, 1903–1940), *Photograph of Josephine Dunn*, 1929. Gelatin silver print, 30.7 × 23.3 cm (12 1/16 × 9 3/16 in.). Los Angeles, J. Paul Getty Museum, 84.XP.684.59

Once worn out of practicality for certain types of farm labor, shorts of all lengths and designs were adopted for sports, acrobatics, and entertainment in the early twentieth century. A daring costume like this would have been worn on stage.

mid-nineteenth-century Europe and the United States, with many revivals—varying in snugness of fit—since.

Trouser strap A strap attached to trouser hem that encircles the instep so that it pulls the legs smooth and prevents them from riding up. It is usually worn under boots.

Tuxedo pants Straight-fitted trousers with a vertical satin stripe on the outer legs; part of the distinctive tuxedo ensemble since the late nineteenth century (SEE SUIT/TUXEDO).

Tuck

A small fold that is stitched into place. Tucks are used to narrow or shorten an element of a garment, such as a bodice, skirt top, or hem. The ease taken in by vertical tucks can be released at the end of the stitching for a bloused effect. Removable tucks allow alteration, adding length or width. Very narrow (quarter inch or less) tucks are called pin tucks. Tucks can be soft, pressed flat, or left standing for decorative effect. Ornamental tucks can be of alternate widths, curved or contoured, or arranged in fan or honeycomb patterns (SEE SMOCKING). The term also refers to the positioning of a shirt or top under the waistband of trousers or a skirt, as in "tucked in" or "untucked."

Tunic

A simple T-shaped garment that pulls on over the head and covers the upper body and part of the legs. The tunic figures in dress history around the world, particularly in ancient Greece and Rome; the name derives from the Latin *tunica*. It may be of any length, have long or short sleeves, and be made of any fabric. Tunics are often worn over other garments, such as a stretchy top, trousers, leggings, or a skirt. The term can also mean a dress without a waistline break or shaping darts, with any length sleeve or sleeveless. It was the signature silhouette of the 1920s "flapper" style.

Mashq-i Mu'in Musavvir (Persian, Safavid dynasty, active 1630–1700), *Portrait of a Youth*, 1676. Ink, opaque watercolor, and gold on paper, 14.3 × 8.5 cm (5⅝ × 3⅜ in.). London, British Museum, 1920,0917,0.298.1

The wrap and decoration of a turban express individuality and signify identity. Here, in a portrait of an idealized youth, the turban is modest but elegant, edged with gold and crowned with a feather aigrette.

Turban

A headdress created from a length of fabric wrapped artfully around the head or a foundation cap. The exact origins are unknown, but some form of the turban can be traced to the ancient cultures of Mesopotamia. Turbans are mentioned in the Old Testament and Vedic literature, and were depicted in sculpture as early as the third millennium BCE. The prophet Muhammad wore a white turban, and while the headwear has distinct religious affiliations—particularly for Sikh and Muslim men—it is worn as a secular garment throughout South and Central Asia as well as North Africa and the Middle East. The manner of wrapping a turban varies widely and reflects regional, cultural, familial, and social identities. Turbans can be plain or patterned, made of silk or cotton, and/or embellished with jewelry. Colors may have a symbolic meaning or a regional association. Introduced in Europe in the fifteenth century through trade, turbans inspired Western variants and alternatives (SEE HOOD/*CHAPERON*). A number of Native American peoples, including Seminole, Creek, and Shawnee, independently developed distinctive turban forms. Since its introduction in Europe, women have adapted the form in fashion. In the twentieth century, small, fitted turbans—often stitched into a stable form—were worn as a glamorous accessory.

Edward Steichen (American, 1879–1973), *Gloria Swanson*, 1924. Gelatin silver print, 27.8 × 21.6 cm (10¹⁵⁄₁₆ × 8½ in.). Los Angeles, J. Paul Getty Museum, 84.XM.848.5

As a woman's fashion accessory in the 1920s, a tight turban enhanced an overall sleek silhouette. Edward Steichen added further glamour here by shooting the film star's portrait through lace.

Undergarments (underwear)

Intimate garments worn under clothing, next to the skin, for modesty, support, and hygiene, usually made of light and washable fabric. They may also provide a layer of warmth, protect skin from the rough texture of an outer garment, or create a fashionable silhouette. The form and function of specific undergarments have varied widely across time, but they have generally been designed in conformance with binary gender divisions (SEE BUSTLE; CAGE CRINOLINE; CORSET; CRINOLINE; SUPPORT).

Bloomers Full-cut, soft drawers for women and children that reach to below the knee and are gathered at the waist and hems. They were promoted as a practical alternative to a skirt by mid-nineteenth-century women's rights activist Amelia Bloomer as an example of dress reform, but never widely adopted. Bloomers were generally worn under a short skirt (above the ankles), for some sports, and by toddlers.

Boxer shorts Men's loose-fit drawers, gathered with elastic or a drawstring at the waist, with open hems and a fastenable fly to facilitate urination. Reaching anywhere from near the top of the thigh to below mid-thigh, boxers were inspired by the shorts worn for the sport of boxing.

Brassiere (bra) A support garment for the breasts. BANDEAUS were used throughout history to support women's breasts, especially for sport, whereas a cupped garment that defines the individual breasts was rare until the early twentieth century; from that point, as corsets became smaller and less restrictive, an alternative garment was sought to support the breasts. The US socialite Caresse Crosby first patented the standard form featuring cups on a band, supported by straps and fastened with hooks, in 1914. Fitted to an individual woman's body by the size of the cups and the circumference of the band, brassieres have varied in response to changing ideas of a fashionable silhouette.

Men's drawers and shirt, France, 1750–75. Linen, hand woven and hand sewn. London, Victoria & Albert Museum, T.607-1996

Styled like breeches, these drawers have a laced yoke back and a button front to facilitate a smooth fit. The tapes at the knee hem the leg, and also secure the stockings.

Briefs Small, snugly fitted drawers made of a knit fabric. The term generally refers to a male garment, but the style is also worn by women. The waist may be anywhere from the natural waistline to below the navel, with leg openings at the very tops of the legs and the buttocks covered. Men's briefs often feature a fly to facilitate urination.

Camisole An underbodice worn between the corset and the skin. It may

141

Winslow Homer (American, 1836–1910), *Croquet Scene*, 1866. Oil on canvas, 40.3 × 66.2 cm (15⅞ × 26¹⁄₁₆ in.). Art Institute of Chicago, 1942.35, Friends of American Art, Goodman Fund

Petticoats worn over cage crinolines were often finished with embroidered bands, pleated flounces, or lace edging. Outer skirts incorporated tapes in vertical casings that raised the hem to display the trimmings.

have straps, or be sleeveless, or have short sleeves. It may be fully functional or decorative, meant to be seen just above the bodice neckline. Camisoles can also be worn as CORSET covers, or worn without a corset.

Drawers A lower-body garment of any design, worn for comfort, modesty, and/or hygiene. Drawers emerged as a distinct garment in Western cultures around the sixteenth century, and the term may derive from the drawstring waist. It has since come to serve as an umbrella term for the layer worn next to the skin beneath BREECHES, trousers, or a skirt.

Garter belt An elasticized band fitted snugly around the waist or hips with suspender slings that are finished with clips or buttons to hold the top of the stocking.

Girdle An elasticized support garment for the lower torso and thighs that smooths and restrains the silhouette, worn by women in the twentieth century. It often features suspenders to support stockings.

Pantalettes (pantaloons) Straight-legged drawers worn by women and girls in the nineteenth century. The hems, right at or above the ankle, were often trimmed with lace or ruffles to be seen beneath the skirt. They often featured an open seam with a lace or button fastening between the legs to facilitate urination.

Partlet A thin layer of cloth worn over the breasts next to the skin, under a kirtle's neckline, by women in the late Middle Ages (SEE GOWN/KIRTLE).

Petticoat An underskirt worn for volume, support, and warmth, made of a stiffening fabric (crinoline, horsehair, tulle) or a warm fabric (flannel), and often layered to achieve a fashionable silhouette, particularly in the mid-nineteenth century. The hems often feature TUCKS to adjust the length and as trimming, along with lace, ruffles, and banding.

Undershirt A light garment, with many variations, worn under the shirt, next to the skin, mostly by men and children. By the later nineteenth century, undershirts were usually made of a very fine knit. It is called a T-shirt (SEE SHIRT/T-SHIRT) when it has a round or V neck and short sleeves, and a tank top or athletic shirt when sleeveless with a scoop neck and deeply cut armholes.

Anne-Louis Girodet de Roussy-Trioson (French, 1767–1824), *Portrait of Jean-Baptiste Belley, Deputy for Saint-Domingue*, 1797. Oil on canvas, 159 × 113 cm (62½ × 44⅖ in.). France, Palace of Versailles, MV4616, INV4962, and LP 105 (Museum of the History of France)

Enslaved as a child, Jean-Baptiste Belley (1746–1805) purchased his freedom and attained the rank of infantry captain in the French Army. He was later the first Black man elected to a political office in France. His uniform here is that of a deputy to the National Convention in Paris.

143

Uniform

Standardized attire worn to identify with a military unit, a civic association, a social group, or a specific profession. Uniforms likely emerged to mark members of a service group—martial, guard, attendants—in ancient societies, and they have since evolved to distinguish rank and accomplishment. A distinctive mode of dress provided by an employer is known as livery, as in the uniforms of officials, members of a court or household, or servants, most notably footmen and chauffeurs. The term "uniform" is also used to speak of an individual's customary dress as associated with work, class, or identity.

Pascal Sébah (Turkish, 1823–1886) and Jean Pascal Sébah (Turkish, 1872–1947), *Female Egyptian Peasant and Child*, ca. 1878. Albumen silver print, 27 × 21 cm (10⅝ × 8¼ in.). Los Angeles, J. Paul Getty Museum, 84.XM.858.2

In some Islamic societies, women wear a variety of veil types to adhere to modesty precepts. This woman's veil drapes her upper body and is secured by a circlet similar to the twisted cord (agal) worn with a keffiyeh.

Veil

A length of fabric, often net, tulle, lace, or sheer, draped over the head, covering the crown and back, the face, or both. Veiling can also be attached to a hat as an overlay, or so that it falls forward over the eyes or face. Veils are worn by women in many cultures in conformance with their religious beliefs in a demonstration of modesty and protection from the gaze of nonfamilial men (SEE BURQA). Bridal attire, an almost universal symbol of purity, often includes a veil that is lifted by the groom after the wedding vows are taken. Throughout history, widows have worn veils as a sign of retreat from their previous status as wives. But just as a veil covers, it also draws attention to what is concealed, and so has been worn and interpreted as a seductive garment, sparking imagination as to what lies beneath the delicate barrier.

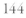

Hijab Worn by observant Muslim women, a headscarf draped around the head and neck, exposing the face and sometimes a bit of the hairline.

Mantilla A length of lace, silk, or velvet, elegantly finished and worn over the head and draping the shoulders, sometimes secured with a high, elaborate comb (*peineta*). A traditional garment in Spanish and Latin American cultures, the mantilla derives from head coverings worn out of respect during church attendance.

Niqab Worn by observant Muslim women, a veil over the lower half of the face along with a concealing headscarf that completely covers the hair. It may be worn with a separate eye veil.

Shayla Associated with the Persian Gulf region, a long, often lightweight headscarf artfully draped around the head and shoulders and tucked or pinned in place.

Waistband

The element of a garment that demarcates the waistline. It can also serve as the top finishing band of a skirt or trousers, gathering or pleating in excess fabric. It may be soft, stiffened with interlining (SEE LINING/INTERLINING), or made adjustable with elastic or a drawstring.

Man wearing top hat and patch over left eye, 1840–60. Daguerreotype, dimensions unknown. Cambridge, Massachusetts, Houghton Library, Harvard University, The Daguerreotypes of Harvard, W162973_1

Waistcoats added interest to the conventional three-piece suit in the mid-nineteenth century. Here, the shawl collar and watch pocket are fairly typical of the period, but the bold plaid of this man's waistcoat signals a defiant individualism.

Waistcoat (vest)

A garment worn on the upper body between a shirt (or other type of top) and an outer garment such as a coat or jacket. Waistcoats for men became fashionable in the sixteenth century in Europe, first worn as a warm layer but soon designed as part of the man's ensemble, meant to be seen at the open front of the outer garment. Early waistcoats often had sleeves; these disappeared by the mid-eighteenth century. The lines of a waistcoat—length, lapels, fastenings, fit—vary according to fashion. Typically they are designed to add flair to an ensemble through a contrasting fabric or ornamental detail. The term "vest" came into general use in the United States in the twentieth century. It also describes utility garments such as flotation vests, fluorescent vests, artillery vests, and bulletproof vests. Over the centuries women have worn waistcoats as decorative garments, and in the twentieth century the garment completely shed its gender identity. Sleeveless, embellished garments can be found throughout the world, particularly as luxury items featuring embroidery, fine fabrics, or fur.

Afghan vest Made from the skin of a curly-haired lamb. The suede side, often elaborately embroidered, is worn on the outside, and the fur on the inside extends past the edges. Based on a traditional herder's garment, it became a fashion item in the West in the 1960s.

Buckskin vest A deerskin, suede garment, generally laced together rather than sewn, trimmed with beadwork and often edged with fringe. A traditional garment of some Native American peoples, this vest was adopted by cowboy culture during the era of US westward expansion and remains a feature of Western wear.

Down vest A warm, quilted garment filled with feathers, down, or synthetic insulation that fastens with snaps or a zipper, worn on its own or as an additional layer under a coat or jacket.

Jerkin An outer garment, usually sleeveless, worn over a doublet by men in the sixteenth and seventeenth centuries; a precursor of the waistcoat.

Pakistani wedding vest A long, semi-fitted garment with a shawl collar (SEE COLLAR/SHAWL COLLAR) worn by a groom or for festivals. Fastened with invisible hooks and worn without an overgarment, the vest is usually made of silk or another luxury fabric and richly embellished with gilt braid, embroidery, mirrors, and/or tassels.

Yelek An embroidered Ottoman waistcoat worn by women. Featuring elaborate embroidery on silk or leather, traditional versions are collarless, have two small side pockets, and end near or just below the hips. Now worn in Turkey by both men and women, they vary in lengths and details, with some even having sleeves.

Waistline

The STYLE LINE that marks the position and contour of the waist. The waistline may be located at, above, or below the natural waist, depending on dictates of style. It may be closely fit, loosely fit, or absent altogether but suggested by the shaping of the garment (SEE GOWN/PRINCESS LINE). The line may be straight, oval, or dipped in the front or back in a curve or V shape. The waistline also functions as a construction seam when it connects the upper and lower halves of a garment.

Cinched waist A very tight, pulled-in waist, causing excess fabric to bunch above and below, generally emphasized with a wide belt.

Drawstring waist A cord or string run through a casing at the waist that allows the wearer to adjust the size of the waistline. Elastic can be also be run through the casing or combined with the drawstring for a more flexible fit.

Dropped waist A waistline located below the natural waist.

Empire waist (Directoire waist, Regency waist) A high waistline, usually right below the bustline, that gathers the fullness of the bodice into a smoother, slimmer skirt. It is named for the slim, simple dresses fashionable in Europe from circa 1790 to the 1820s. It may have a band or a drawstring (SEE GOWN/CHEMISE).

High waist A waistline located above the natural waist but below the bustline. It may also indicate the top line of a skirt or trousers that rises above the natural waist (as in "high-rise").

Set-in A sewn-in band that encircles and defines the waist.

Wimple

A strip of linen or silk wound around a woman's head over the cheeks and chin and sometimes the neck as well. During the later Middle Ages in Europe, a wimple was usually paired with a horned or butterfly hennin (molded hat) or head drape

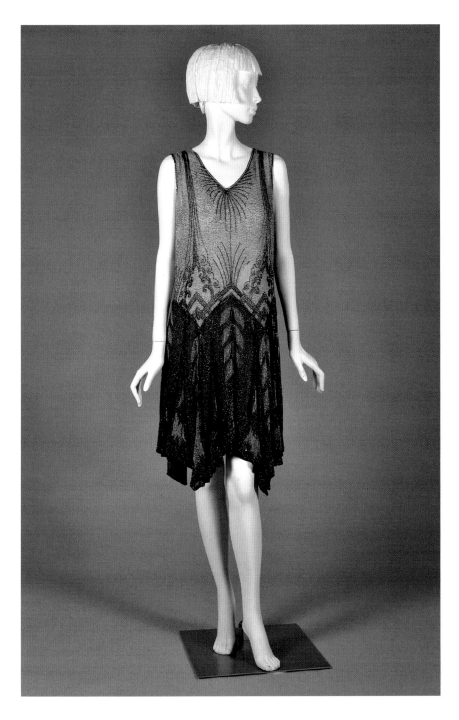

Beaded dress, American, ca. 1927. Silk chiffon and beads. Kent, Ohio, Kent State University Museum, Silverman Rodgers Collection, KSUM 1983.1.383

The absence of a fitted waistline is as import-ant to this gown's silhouette as a defined seam would be in a different dress. The elegant tunic skims the body, and the pointed hem of the bodice hints at a defining style line of the 1920s: the dropped waistline.

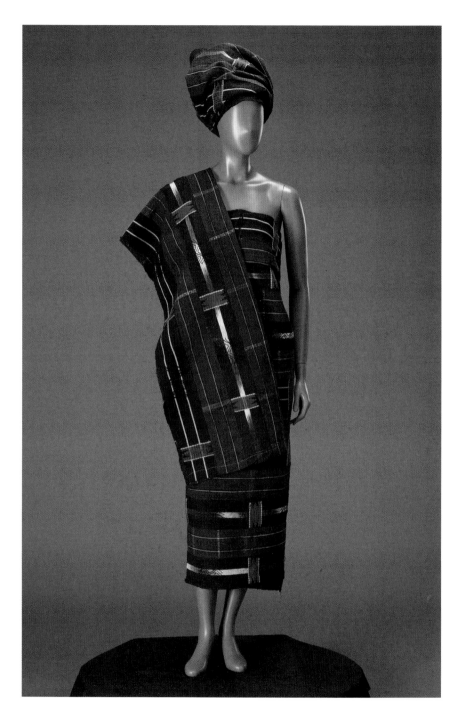

Women's body wrapper (*iborum*), Yoruba people, West Africa, 1970s. Cotton, resist-dyed (ikat). Indianapolis Museum of Art, 1987.175, Costume Fund

The slim wrapped dress, shoulder shawl, and head wrap present a modern interpretation of a traditional Yoruba special-occasion ensemble worn by upper-class women. The simple elegance of the style lines emphasizes the beauty of the woven textiles.

(*couverchef*; SEE HEADWEAR). A wimple usually covered a woman's hairline and identi-fied the wearer as modest, married, or perhaps a widow. The form has survived in the habits of some women's religious orders.

Wrap

To lap a length of cloth around the body to create a garment. This basic form of clothing construction can be found throughout history and across all cultures. The cloth can be wrapped around the body in a column (SEE SARONG; WRAPPER), pleated for volume and closed with an overlap (SEE KILT), or cut into a conventional garment that features a closure with one side lapping over the other and secured with a tie or fasteners. A simple overgarment worn for warmth is also called a wrap.

Wrapper

A garment created by wrapping a length of cloth around the body and tucking or tying the loose end. Wrappers in the form of skirts or dresses can be found across the globe, from the Tahitian pareu to the Filipino *malong*, the Malayan SARONG, the Cambodian *sampot*, the Yemeni *fūṭah*, the West African *lappa*, and the Scottish KILT (SEE HIMATION; WRAP). In Western cultures, "wrapper" also describes an informal housedress or dressing gown (SEE ROBE/DRESSING GOWN).

Yoke

A panel of fabric shaped to the shoulder and neckline that covers the upper third or less of the torso. The lower portion of the garment—a dress, blouse, or jacket— is attached to the lower edge of the yoke, with its additional fullness eased or pleated into the seam. A yoke may be positioned on the front, the back, or both, and it is generally doubled or lined for support and occasionally trimmed with SMOCKING. In European-based traditions, yokes are used on robes, smocks, and aprons; in children's wear; in house dresses (as in the Mother Hubbard dress or apron); as a reinforcing element across the back of a man's shirt; and as a style element in fashions such as tea gowns, smock blouses, smock dresses, and baby doll dresses (SEE APRON; GOWN/TEA GOWN; SHIRT; SMOCK). The distinctive Hawaiian holoku features a yoke.

149

Zipper

A fastener constructed of two parallel rows of metal or plastic teeth, attached to fabric tapes, that interlock with a sliding tab. A US invention, zippers were first marketed in 1891 by Whitcomb L. Judson as "clasp lockers." In 1925 the B. F. Goodrich Company trademarked the name "zipper" for their rubber Zipper Boots, and the name came into popular use as new forms of zippers were designed for trousers, dresses, and other garments. A zipper may be hidden under a placket, inserted in a seam (when in the left side of a gown, this is known as a dressmaker zipper), or exposed as a decorative element.

Further Reading

Brasser, Theodore. *Native American Clothing: An Illustrated History*. Richmond Hill, Ontario: Firefly Books, 2009.

Brooks, Mary M., and Dinah D. Eastop, eds. *Refashioning and Redress: Conserving and Displaying Dress*. Los Angeles: Getty Conservation Institute, 2016.

Bruna, Denis, ed. *Fashioning the Body: An Intimate History of the Silhouette*. New Haven, CT, and London: Yale University Press, 2015.

Calasibetta, Charlotte Mankey, and Phyllis Tortora. *The Fairchild Dictionary of Fashion*. 3rd ed. New York: Fairchild, 2009.

Callan, Georgina O'Hara, and Cat Glover. *The Thames & Hudson Dictionary of Fashion and Fashion Designers*. 2nd ed. London: Thames & Hudson, 2008.

Condra, Jill, ed. *The Greenwood Encyclopedia of Clothing through World History*. 3 vols. Westport, CT: Greenwood Press, 2008.

Cumming, Valerie. *Gloves*. Costume Accessories Series, edited by Aileen Ribeiro. London: B. T. Batsford, 1982.

DK/Smithsonian. *Fashion: The Definitive History of Costume and Style*. London: DK; New York: Smithsonian, 2012.

Edwards, Lydia. *How to Read a Dress: A Guide to Changing Fashion from the 16th to the 20th Century*. London: Bloomsbury Academic, 2017.

——. *How to Read a Suit: A Guide to Changing Men's Fashion from the 17th to the 20th Century*. London: Bloomsbury Visual Arts, 2020.

Finlay, Victoria. *Fabric: The Hidden History of the Material World*. New York: Pegasus Books, 2022.

Ford, Richard Thompson. *Dress Codes: How the Laws of Fashion Made History*. New York: Simon & Schuster, 2021.

Gänsicke, Susanne, and Yvonne J. Markowitz. *Looking at Jewelry: A Guide to Terms, Styles, and Techniques*. Los Angeles: J. Paul Getty Museum, 2019.

Hug, Catherine, and Christopher Becker. *Fashion Drive: Extreme Clothing in the Visual Arts*. Zurich: Kunsthaus Zürich, 2018.

Laver, James. *Costume and Fashion: A Concise History*. 6th ed., with updates by Amy de la Haye and Andrew Tucker. London: Thames & Hudson, 2022.

Leventon, Melissa, ed. *What People Wore When: A Complete Illustrated History of Costume*. New York: St. Martin's Griffin, 2008.

Martineau, Paul. *Icons of Style: A Century of Fashion Photography*. Los Angeles: J. Paul Getty Museum, 2018.

McKever, Rosalind, and Claire Wilcox with Marta Franceschini, eds. *Fashioning Masculinities: The Art of Menswear*. London: V&A Publishing, 2022.

Milbank, Caroline Rennolds. *Fashion: A Timeline in Photographs: 1850 to Today*. New York: Rizzoli International, 2015.

Phipps, Elena. *Looking at Textiles: A Guide to Technical Terms*. Los Angeles: J. Paul Getty Museum, 2011.

Porter, Charlie. *Bring No Clothes: Bloomsbury and the Philosophy of Fashion*. London: Particular Books, 2023.

Redwood, Mike. *Gloves and Glove Making*. Oxford: Shire, 2016.

Ribeiro, Aileen. *Clothing Art: The Visual Culture of Fashion, 1600–1914*. New Haven, CT, and London: Yale University Press, 2017.

Rivers, Victoria Z. *The Shining Cloth: Dress and Adornment That Glitter*. New York and London: Thames & Hudson, 1999.

Ryan, Mackenzie Moon. *African Apparel: Threaded Transformations across the 20th Century*. New York: Scale Arts; Winter Park, FL: Cornell Fine Arts Museum, Rollins College, 2020.

Scott, Margaret. *Fashion in the Middle Ages*. Los Angeles: J. Paul Getty Museum, 2018.

Steele, Valerie, ed. *Encyclopedia of Clothing and Fashion, The Scribner Library of Daily Life*. 3 vols. Detroit: Thomas Gale, 2005.

——. *The Berg Companion to Fashion*. Oxford and New York: Berg, 2010.

Takeda, Sharon Sadako, Kaye Durland Spilker, and Clarissa M. Esguerra. *Reigning Men: Fashion in Menswear, 1715–2015*. Munich, London, and New York: Los Angeles County Museum of Art and DelMonico Books, an imprint of Prestel, 2016.

Thanhauser, Sofi. *Worn: A People's History of Clothing*. New York: Pantheon Books, 2022.

van Buren, Anne H., with Roger S. Wieck. *Illuminating Fashion: Dress in the Art of Medieval France and the Netherlands, 1325–1515*. New York: Morgan Library, 2011.

Walters, Linda, and Abby Lillethun. *Fashion History: A Global View*. London: Bloomsbury Visual Arts, 2018.

Acknowledgments

Transforming an idea into a book is never a solitary endeavor, and I would like to thank all those who contributed to *Looking at Fashion*. I am very grateful to the team at Getty Publications, including Victoria Gallina, Dani Grossman, Nancy Rivera, Kate Justement, Candice Lee, Clare Davis, and Kara Kirk.

A special thanks to former editor in chief Karen Levine for helping to conceive and launch the book. My deepest gratitude goes to my editor Ruth Evans Lane for her insightful guidance, good humor, and true spirit of collaboration. Thank you to copy editor Lindsey Westbrook for her sharp eye and perceptive questions, to A. E. Kieren for his dazzling drawings, and to proofreader Anne Canright for her attention. My thanks to the Newberry Library in Chicago for their ongoing support of my research, with special recognition of JoEllen McKillop Dickie and the superb reference staff. Thanks also to Yoojin Choi at the Victoria & Albert Museum for answering several queries. For sharing their expertise at the early stages of the project I want to recognize Kristan M. Hanson and Eileen Read and, for their interest, Timothy Long and Virgil Johnson. To my friends Archie Harders, Paul B. Jaskot, Stan Piotroski, Versell Smith, Jeanne Steen, Robert Wieber, and Patricia Wieber, thank you for listening to me talk about the project with patience and encouragement. And a special nod of gratitude to my ally in all things fashion, Michal Raz-Russo, for her ever-ready and spot-on suggestions and her unflagging fascination with the meaning of what we wear and how we wear it.

This book was written in memory and honor of my mother, Elinor R. Mancoff, who taught me at an early age that there was more to clothes than passing fashion.

Illustration Credits

Front cover, p. 63: © Amy Sherald / Courtesy the artist and Hauser & Wirth / Photo: Joseph Hyde; pp. 1, 79, 81, 110: Photo: www.lacma.org, CCO; p. 10: © Museo Nacional del Prado / Photo: Art Resource, NY; p. 13: © Norman Parkinson Ltd / Photo: Courtesy Norman Parkinson Archive; p. 14: Kimball Art Museum, Fort Worth, Texas; p. 15: (below) CPA Media Pte Ltd / Photo: Alamy Stock Photo; p. 16: Ian Dagnall Computing / Photo: Alamy Stock Photo; p. 17: (above) © Worcester Art Museum / Photo: Bridgeman Images; (below) © Estate of Isabel Bishop. Courtesy DC Moore Gallery, New York / Photo: Saint Louis Art Museum; p. 18: (above) © Robert Mapplethorpe Foundation. Used by permission; pp. 19, 39, 60, 61, 88 (above), 94, 118 (below): © The Metropolitan Museum of Art / Photo: Art Resource, NY; p. 20: (above) Photo: © 2024 Museum of Fine Arts, Boston; (below) National Portrait Gallery, London; pp. 21 (above),103: Photo: Tate; p. 21: Photo: © Denver Art Museum; p. 24: © Paula Rego / Bridgeman / Photo: Courtesy Sotheby's, Inc. © 2023; p. 26: © Rheinisches Bildarchiv Cologne, rba_d000244; p. 28: © 2023 Romare Bearden Foundation / Licensed by VEGA at Artists Rights Society (ARS), NY / Photo: © Detroit Institute of Arts / Bridgeman Images; p. 31: © 2023 Banco de México Diego Rivera Frida Kahlo Museums Trust, Mexico, D.F. / Artists Rights Society (ARS), NY / Photo: Museo de Arte Moderno, Mexico City; pp. 33, 121, 128, 130: Photo: www.met.org, CCO; p. 37: Photo: Gabinetto Fotografico delle Gallerie degli Uffizi; pp. 40, 87, 143: © RMN-Grand Palais / Photo: Art Resource, NY; pp. 41 (above), 80, 88 (below), 91, 92, 140 (above): Photo: © The Trustees of the British Museum; p. 42: © Lalla Essaydi, Courtesy the artist and Edwynn Houk Gallery, New York / Photo: Courtesy National Gallery of Art, Washington, DC; p. 43: Imaginechina Limited / Photo: Alamy Stock Photo; p. 45: © Paris, Les Arts décoratifs / Photo: Jean Tholance; p. 46: CCO Paris Musées / Photo: Petit Palais, Musée des Beaux-Arts de la Ville de Paris; p. 47: © Museo Nacional del Prado / Photo: Art Resource, NY; p. 50: Photo: Kansas Historical Society; p. 51: Photo: Courtesy National Gallery of Art, Washington, DC; p. 52: Photo: © IWM Art.IWM ART LD 2850; pp. 55, 134 (below): Photo: © The National Gallery, London; p. 56: © 2023 Banco de México Diego Rivera Frida Kahlo Museums Trust, Mexico, D.F. / Artists Rights Society (ARS), New York / Photo: © The Museum of Fine Arts Houston; Will Michels; p. 65: PA Images / Photo: Alamy Stock Photo; p. 67: The Frick Collection, New York / Photo: Joseph Coscia Jr., © The Frick Collection; p. 69: Image courtesy The Textile Museum Collection, Washington, DC / Photo: Breton Littlehales; p. 72: © William Hustler and Georgina Hustler / Photo: National Portrait Gallery, London; pp. 75, 89, 98 (below), 102, 141: Photo: © Victoria and Albert Museum, London. p. 78: Photo: © KHM-Museumsverband; p. 82: (above) © Kehinde Wiley / Photo: Courtesy Detroit Institute of Arts; (below) The Art Institute of Chicago / Photo: Art Resource, NY; p. 83: Royal Collection Trust / Photo: © His Majesty King Charles III 2023; p. 84: Digital Image © 2024 Museum Associates / LACMA / Photo: Art Resource, NY; p. 85: Collection KMSK-Flemish Community / Photo: Cedric Verhelst; p. 96: © Tomoko Sawada; p. 97: © Charles James Sarl / Photo: Courtesy Kent State University Museum. p. 105: Photo: National Art Museum of Azerbaijan; p. 111: © The Estate of Alice Neel / Courtesy the Estate of Alice Neel and David Zwirner / Photo: Dan Bradica; p. 115: © Chicago History Museum / © Estate of Archibald John Motley Jr. All reserved rights 2023 / Photo: Bridgeman Images; p. 118 (above): SuperStock / Photo: Alamy Stock Photo; p. 126: Mairie de Bordeaux / Photo: Musée des Beaux-Arts. p. 129: © 2023 Tamara de Lempicka Estate, LLC / ADAGP, Paris / ARS, NY / Photo: © Christie's Images/ Bridgeman Images; p. 132: © Richard Woodward / Photo: National Museum, Liverpool p. 133: © William Claxton / Photo: © William Claxton, courtesy Demont Photo Management, LLC; p. 135: © Yinka Shonibare CBE. All rights Reserved, DACS / ARS, NY 2023 / Photo: The Art Institute of Chicago / Art Resource, NY. p. 142: Photo: www.aic.com, CCO; p. 144: Photo: Harvard University, Houghton Library; p. 147: Photo: Kent State University Museum; p. 148: Photo: www.collections.discovernewfields.org, CCO

Index

153

159

Published by Getty Publications, Los Angeles
1200 Getty Center Drive, Suite 500
Los Angeles, CA 90049-1682
getty.edu/publications

Ruth Evans Lane, *Project Editor*
Lindsey Westbrook, *Manuscript Editor*
Dani Grossman, *Designer*
Victoria Gallina, *Production*
Nancy Rivera, *Image and Rights Acquisition*
Illustrations by A. E. Kieren

Distributed in the United States and Canada
by the University of Chicago Press

Distributed outside the United States and
Canada by Yale University Press, London

MIX
Paper | Supporting
responsible forestry
FSC® C016973

Printed in Malaysia

Library of Congress Cataloging-in-Publication Data
Names: Mancoff, Debra N., 1950– author.
Title: Looking at fashion : a guide to terms, styles, and techniques /
 Debra N. Mancoff.
Other titles: Looking at.
Description: Los Angeles : Getty Publications, [2024] | Series: [Looking
 at] | Includes bibliographical references and index. | Summary: "This
 illustrated guide offers accessible, concise explanations of key fashion
 terms and describes and explains the most essential components of
 garments and techniques of clothing construction"— Provided by
 publisher.
Identifiers: LCCN 2023051774 (print) | LCCN 2023051775 (ebook) | ISBN
 9781606068991 (paperback) | ISBN 9781606069011 (epub) | ISBN
 9781606069004 (adobe pdf)
Subjects: LCSH: Clothing and dress—Terminology. | Fashion—Terminology. |
 LCGFT: Dictionaries.
Classification: LCC TT494 .M36 2024 (print) | LCC TT494 (ebook) | DDC
 746.9/2014—dc23/eng/20240130
LC record available at https://lccn.loc.gov/2023051774
LC ebook record available at https://lccn.loc.gov/2023051775

The complete manuscript of this work was peer reviewed through
a single-masked process in which the reviewers remained anonymous.

Front cover: Amy Sherald, *Miss Everything
(Unsuppressed Deliverance)*, 2014. © Amy Sherald.
Courtesy the artist and Hauser & Wirth. See p. 63
Back cover: drawings by A. E. Kieren
Page 1: Unknown artist, Mughal Empire, *Prince with a Falcon*,
1600–1605. Opaque watercolor, gold, and ink on paper,
14.9 × 9.5 cm (5⅞ × 3¾ in.), Los Angeles County Museum
of Art, from the Nasli and Alice Heermaneck Collection,
Museum Associate Purchase, M.83.1.4

Illustration Credits
Every effort has been made to contact the owners and photographers of
illustrations reproduced here whose names do not appear in the captions
or in the illustration credits listed on p. 152. Anyone having further information
concerning copyright holders is asked to contact Getty Publications so this
information can be included in future printings.